GRAMERCY GREAT MASTERS

Pierre Auguste Renoir

Gramercy Books
New York • Avenel

Acknowledgments

The publishers would like to thank the museums for reproduction permission and in particular the **BRIDGEMAN ART LIBRARY** for their help in supplying the illustrations for the book.

Christie's, London: In the Forest of Fontainebleau; Nude in the Water; Pierre Renoir; Paul Charpentier; Vase of Flowers; Gabrielle; Portrait of Henry Bernstein; Girl Wearing a Straw Hat; Girl with a Pink Ribbon; Apples and Pears; The Farmhouse at Cagnes; Still Life with Pheasants.
Cleveland Museum of Art: Portrait of Mademoiselle Romaine Lacaux.
Courtauld Institute Galleries, University of London: La Loge; Portrait of Ambroise Vollard.
Louvre, Paris: Bather Called Eurydice, Sitting in the Country; Gabrielle with a Rose; At the Piano; Portrait of a Child; Sketch for The Bathers.
Metropolitan Museum of Art, New York: Bather with Long Hair.
Museo de Arte, Sao Paulo: Bather with a Griffon Terrier; The Cahen d'Anvers Girls; Bather Sitting Drying Her Leg.
Musée d'Orsay, Paris: The Swing; Le Moulin de la Galette; Alphonsine Fournaise on the Island of Châtou; Dancing in Town; Gabrielle and Jean.
Museum of Fine Arts, Boston: Dancing at Bougival.
Nasjonalgallerie, Oslo: Girl Bathing.
National Museum of Wales, Cardiff: The Parisian Girl.
National Gallery, London: The Umbrellas; Girl with a Watering Can; Blonde Girl Combing Her Hair; Dancer with Castanets.
Phillips Collection, Washington: The Luncheon of the Boating Party.
Palace of Legion of Honor, San Francisco: Mother and Child.
Philadelphia Museum of Art: The Bathers.
Private collections: La Grenouillère; Spring in Châtou; Gipsy Girl; Three Women in the Park; Female Nude on a Couch; The Bathers; Nude in the Grass; The Breakfast at Berneval.
Wallraf-Ricartz Museum, Cologne: The Painter Sisley and His Wife.

Pierre Auguste Renoir
His Life and Works

"You undoubtedly paint just to amuse yourself," remarked the academic painter Charles Gleyre disparagingly to Pierre Auguste Renoir, a recent arrival at his teaching studio in the formal École des Beaux-Arts in Paris. "But, of course," the young pupil replied. "If painting didn't amuse me, I can assure you that I would not be here doing it."

This anecdote, related by Renoir's biographer Albert André, sums up Renoir's essential attitude toward his painting—enjoyment in the highest sense of the word, a joy renewed every time his paint formed images on the canvas, a sensuous pleasure and celebration of life. This joy was inherent in Renoir's art, as much a part of each of his paintings as the luminous skin tones, the sun-dappled trees, or the rich brushstrokes of bright color. The joy was always there.

Renoir was drawn to the swiftly beating pulse of life, to the vital energy of nature that urges every living thing to grow and flourish, that permeates everything and everyone with the simple and eternal beauty of the world. People enjoying lunch at a riverside café . . . a couple dancing cheek to cheek . . . an exquisite nude plaiting her hair . . . a woman, pale and luminous, dressed for the opera . . . a family picking apples in the country . . . a glowing child playing in the garden. . . . These were the subjects Renoir chose to paint in response to his instinctive desire to glorify life.

While the other Impressionists were searching for a new and lyrical interpretation of reality, a blend of observation and emotion, realism and imagery, Renoir tried to capture the essence of people. To that end, he experimented with many styles and techniques, from the strict, rigid lines of neoclassicism to the spontaneity of Impressionism, from using thick, loose swirls of color to composing concise, clear forms. He even experimented with a formal classical style, echoing the masters of the Renaissance.

But always, Renoir had an intense emotional involvement with his subjects and a rich feeling for color and texture. The people he painted were immediately transformed into fascinating creatures involved in a celebration of life. Every detail in his paintings glows with luminous tones and exquisite grace, and the subjects emanate a tender, dreamlike quality.

If Toulouse-Lautrec represented the darker side of Impressionism, then Renoir represented its light. If Monet, Manet, and Pissarro represented the shape, form, and philosophy of Impressionism, then Renoir represented its spirit. "I like paintings that make me want to stroll into them if they show landscapes, or to fondle them if they show women," he said.

Renoir is a great master of joyous Impressionist art. He was a man who embraced life, no matter how great were his problems or his pain. He is an artist whose paintings give a glimpse of the wonders and happiness in the human soul.

THE EARLY YEARS

Pierre Auguste Renoir was born on February 25, 1841, in Limoges, France. He was the fourth of five children. When Renoir was four years old, his father, a poor tailor, moved the family to Paris, but unfortunately it did not improve their economic situation.

Renoir was a good-natured child, and even the doodling he did in his schoolbooks showed he had talent. He also excelled in singing, so much so that the choirmaster at Église Saint-Roch, where Renoir was a choirboy, suggested he pursue music as a career. But his gift for drawing won out and, at the age of thirteen, Renoir was apprenticed to a porcelain painter because his father believed that the ceramics industry would provide a secure future for him.

Although he was paid a pittance, Renoir did his work with good

humor. On bowls and cups and plates he painted small flowers, little nosegays, even the profile of Marie Antoinette. "I might add," he once told Ambroise Vollard, an art dealer and close friend, "that the owner took good care to stamp everything with the Sèvres mark, borrowed for the occasion."

Renoir's apprenticeship as a porcelain painter was not ill-spent. He learned how to paint with delicate brushstrokes, using thin, luminous colors. He also discovered the Louvre. While he munched a sausage, he explored its halls, its grounds, and the nearby fountains, where he discovered his predilection for the rounded forms of women's bodies and for art that joyously celebrated life. After four years of apprenticeship, Renoir's career in the ceramics industry ended because new mechanical "assembly lines" decreased the job opportunities for skilled porcelain painters.

Renoir already knew he wanted to paint. In 1857, he finished his first known painting, a portrait of his grandmother. But he still needed to earn a living. Fortunately, his older brother, a medal engraver, offered him a job painting fans. At seventeen, Renoir began painting Boucher's *Bath of Diana* and other popular classics on elegant fans. But that job, too, paid little, so Renoir soon switched to painting blinds to look like stained-glass windows, for missionaries.

Painting blinds proved profitable and before long Renoir had enough money to enroll in the established École des Beaux-Arts. In 1862, he stopped painting blinds and began attending Gleyre's teaching studio in 1862.

Renoir was less than enthusiastic about Gleyre's conventional style, but he threw himself into learning the fundamentals of painting, the basics of technique and composition. Whenever they could, Renoir and his new friends, fellow students Claude Monet, Frédéric Bazille, and Alfred Sisley, would escape from the conservative academy and travel to the Forest of Fontainebleau, where they could paint in the open air to their heart's content. Instead of the tedious mythological subjects, classic themes, and grand-scale heroics that were taught at the Paris academy, these painters could portray the here and now. They could evoke a mood with color and brushstroke. They could make paintings that were spontaneous, immediate, and fresh.

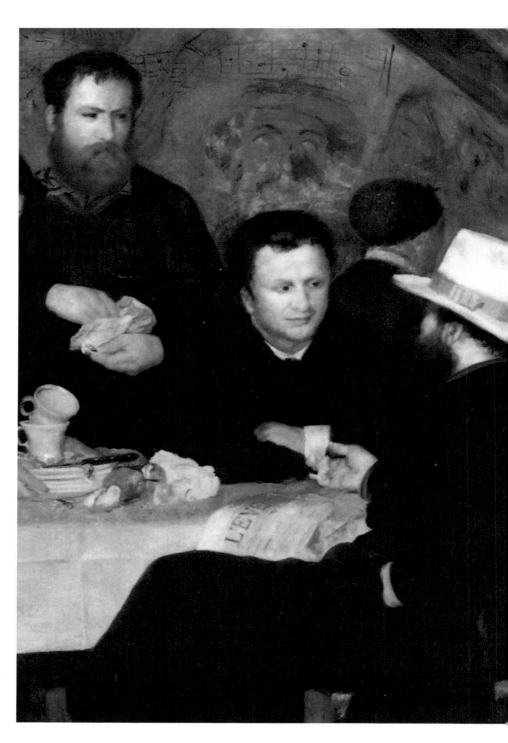

At the Inn of
Mother Anthony
(detail)

THE FOREST OF FONTAINEBLEAU

Certainly, the Impressionists did not invent outdoor painting; nor did they discover the Forest of Fontainebleau. Since the days of Louis XV in the eighteenth century, artists had been drawn to the forest's "picturesque" surroundings, the narrow roads furrowed with deep cart tracks, the cottages surrounded by high walls of earth and straw, the soaring trees and meadows dappled with shadow and light. During the summers of the 1860s, the forest belonged to the Barbizon school, the precursors of the Impressionists, who believed in painting simple, natural settings and subjects. Its members, including Théodore Rousseau, Gustave Courbet, François Millet, and Narcisse Diaz, would go to the forest and discuss painting and life.

For the young, brash Renoir, Bazille, Sisley, and Monet, the forest provided the freedom, the dappled light, and the ever-changing shapes and forms with which they needed to experiment in developing their new style of art.

Renoir frequently lacked the money to take a train to the forest, so he would trek on foot. He sometimes worked side by side with his friends; other times, he would go off by himself. One day he was painting a forest scene in a clearing when a group of hecklers came upon him. They began to laugh at the porcelain-painter's apron that Renoir was wearing and to taunt him. Suddenly, from between the trees strode a tall, burly man, brandishing a walking stick. It was Narcisse Diaz. The hecklers quickly dispersed as Diaz looked at Renoir's easel. "Not badly drawn," he supposedly said, "but why the devil do you paint so dark?" He suggested Renoir look more closely at nature and use its immense variety of bright colors and light.

This chance encounter had a profound effect on Renoir. Diaz had been his ideal. "In Diaz, I can even smell the mushrooms, the rotting leaves, and the moss," he wrote years later to his son. Renoir began to observe his surroundings more closely. He began to loosen up and paint exactly what he saw, as well as the joy he felt when he painted.

A turning point had been reached and Renoir was on his way to becoming a full-fledged artist.

OUTSIDE INFLUENCES

By 1864, Renoir was sharing studio space on the Rue de la Condamine with Bazille. His friends Alfred Sisley and Claude Monet often stopped by. He drank coffee at the Café Guerbois with Manet, Pissarro, Cézanne, and other young Impressionists. For the next six years, his work developed more and more impressionistic overtones as he became heavily influenced by his friends, especially Manet and Monet, by the great masters of the past, and by the members of the Barbizon school, most particularly Gustave Courbet—who worked quickly and used a palette knife to create shadows and dark textures.

Renoir was also influenced by Jean-Baptiste Camille Corot, a painter of the Barbizon school who had the greatest influence among the conservative Académie des Beaux-Arts members. Because of Corot's intervention, the Salon exhibitions finally included the work of some of the new "upstart" Impressionists.

Then there was Delacroix, with his masterful odalisques, his sensual, luminous nudes, and exotic settings. His influence can be seen in Renoir's 1870 painting *The Woman of Algiers*, which shows a smoldering odalisque in an opulent oriental costume. It is painted with the dark-toned palette that would evolve into the ochres, vivid reds, and almost pearlized colors Renoir used during his Impressionist stage. Even Goya and Raphael had some effect on Renoir's work.

Despite these influences, Renoir's intensely personal style was always evident. He might have several different textures and styles in one painting, but they worked together to make an iridescent whole. *Portrait of Madamoiselle Romaine Lacaux* is a good early example. In 1864, when Renoir was only twenty-five years old, he painted the enchantingly delicate portrait of a daughter of a close friend. The cold, almost silvery colors are reminiscent of Corot, while the sweeping brushstrokes and rich tonal contrasts evoke Manet. But the sensitive, confident handling of the girl could only have been painted by Renoir, who had a marvelous capacity to paint children with a tenderness than never lapsed into sentimentality.

Renoir's *Still Life*, which he also painted in 1864, is an unusual composition of plants and flowers in which the influence of Courbet can be seen, especially in the dominance of dark shades.

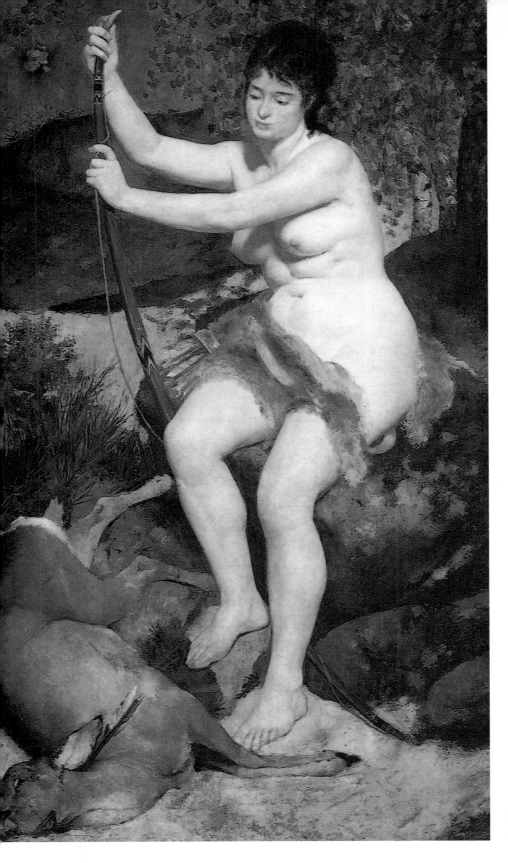

Diana
(detail)

By 1866, Renoir was developing a lighter style, mixing more swirling impressionistic brushstrokes and ambiguous backgrounds with the clear lines of a dress, a face, tendrils of falling hair. *At the Inn of Mother Anthony* displays Renoir's affinity for the modern world. He has attempted to progress beyond Courbet's density and to render light in a more vibrant and agile manner.

In its economy, lack of concern for spatial perspective, and flat colors, the influence of Manet is evident in *Frédéric Bazille at his Easel*. Painted at the studio Renoir shared with Bazille, usually in the company of Monet and Sisley, there is in the uppermost corner a painting of a snow scene that Monet had been working on. And on the easel there is a still life of a heron that Bazille and Sisley had been working on at the time. This painting is, therefore, a symbol of the friendship Renoir felt for his friends. Manet loved the painting and Renoir gave it to him. Years later, Manet gave it to Bazille's father, who was mourning the loss of his son in the Franco-Prussian War.

But Renoir's *Diana*, painted in 1867, moves away from early Impressionism and shows Courbet's influence. Lise Tréhot, his first and one of his most successful models, is painted as a luminous, pensive nude interpreting a classical theme. She holds an arrow; a deer lies dead at her feet. Both she and the deer are clearly delineated, yet the Forest of Fontainebleau in the background is filled with the thick brushstrokes of pre-Impressionism. Renoir submitted *Diana* to the Salon of 1867, but despite its classical overtones, it was not accepted.

Rejection by the staunch, conservative Académie des Beaux-Arts Salon came as no surprise.

SALON VICTORY

In Paris, the Salon was the official arbiter of culture and art. Powerful and conservative, the Academy's annual Salon exhibitions dictated popular artistic taste. In nineteenth-century Paris, there were no galleries where dealers, critics, and the general public could browse. To see new paintings, and buy them, they had to rely on the annual exhibitions. Artists tried hard to have their work accepted because with that acceptance came fame and money. Even the École des Beaux-Arts, where young artists

learned to paint in the approved, conventional way, was a part of the Academy.

The work of the Impressionists was rarely accepted by the Academy, and then only if it was "safe," imbued with a classical, mythical theme, composed with strong, clear lines, or portraying a realistically rendered bucolic scene or figure.

In 1864, after Renoir won tenth place among 106 entrants in a competition organized by the Academy, he was given a spot on the exhibition wall. Although *Esmeralda Dancing* was displayed at the Salon of 1864, Renoir hated its conventional romantic subject and he later destroyed the painting.

The following year, the Salon accepted Renoir's *Portrait of William Sisley* and *Summer Evening*. But it was not until 1868 that he had another painting, *Lise with a Sun Shade*, shown at the Salon. This work of great beauty demonstrates a maturity of style and a new, highly individual artistic identity. It has a luminous variety of colors, blending and harmonizing, with the figure in white, shaded by the umbrella, perfectly in tune with the setting.

Lise with a Sun Shade was a groundbreaking work of art, as much a turning point in European painting as Manet's *Déjeuner sur l'Herbe*, with its classical nude peacefully enjoying a picnic at the river, had been a year before. "The effect is so natural and life-like that we must find it false, given that we are accustomed to representing nature in conventional colors," wrote an art critic about *Lise*. Indeed, Renoir's handling of the shadows, colored by reflections from the trees, was so new a technique that it astonished all who saw it. It allowed painting to be more attuned to the natural world in an extremely realistic way—without the artificial use of light-and-dark painterly chiaroscuro or the neutral tones that flatten classical paintings. Other great Renoir paintings, however, were not accepted for the official Salon exhibitions.

In the meantime, Renoir developed his own unique style. In *The Painter Sisley and his Wife*, for example, although the subject matter, overall composition, and vivid use of color in the couple's clothing were strongly influenced by Monet, the rounded figures and the play between light and shadow as they flicker over the clothing and their faces, can only be Renoir.

In 1868, Renoir also experimented with landscape paintings. His *Skaters at the Bois de Boulogne* shows his unique, spontaneous

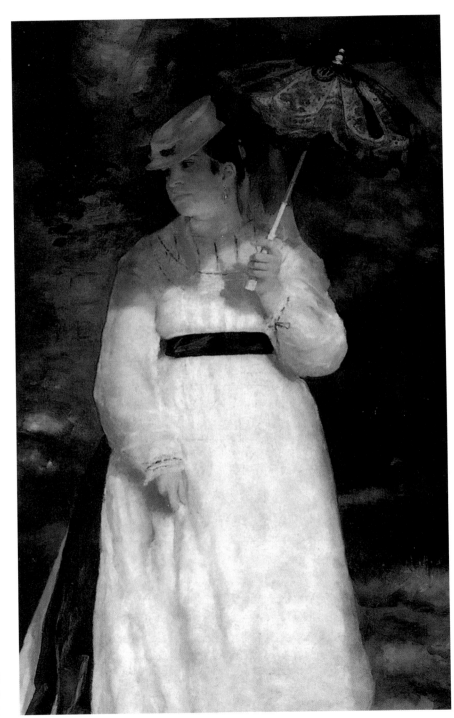

*Lise with a
Sun Shade*
(detail)

brushwork and the wonderful exhilaration he always captured in his bustling scenes of human celebration.

The Seine River played a role in Renoir's paintings during this period. Painting next to Monet, he would observe the reflections of sunlight on the moving river, realizing that the variety of colors would have to be separated to reproduce the reflections on the water. Renoir would then apply this separation to every element of his landscape, identifying the subject "in its tones and not in the subject itself."

Renoir's series of river paintings includes *La Grenouillère*, which shows this floating café moored to a branch of the Seine, surrounded by carefree people in the summer sun. With the cool, crystal-clear blue of the water, and the lush, sun-dappled greenery, Renoir re-creates the remarkably sedate and leisurely atmosphere of the era. He originally sketched the joyous scene as a painting for a Salon acceptance, but he changed his mind when he realized that the briskness and spontaneity of the picture would be lost if he tried to stay within the strict confines of the Salon's requirements.

Impressionism was born and developed as Renoir and Monet created almost identical vivid, spontaneous paintings along the Seine and as other talented artists integrated splashes of color into their landscapes, into their shadows and images.

But in 1870, Renoir reverted once again to classical roots. The Salon accepted his *Bather with Griffon Terrier*, with its strong Courbet influence and classic lines combined with thick background brushstrokes, and *Woman of Algiers*, with the hint of Delacroix in its color and odalisque subject.

Impressionism could not be stopped, however, and Renoir would find a way to embrace it and make it his. He would find a style that recreated a fantastic and idyllic world without having to resort to mythological themes. He would use such images drawn from daily life as a woman on a swing, a girl holding a watering can in a garden, dancers at a festive ball, and nude bathers. The world would soar as Renoir painted it in celebration and joy. But before Renoir's glorious relationship with Impressionism began, there was the war.

In the Franco-Prussian War of 1870, many of Renoir's friends were conscripted, including Bazille, who, sadly, died at the front.

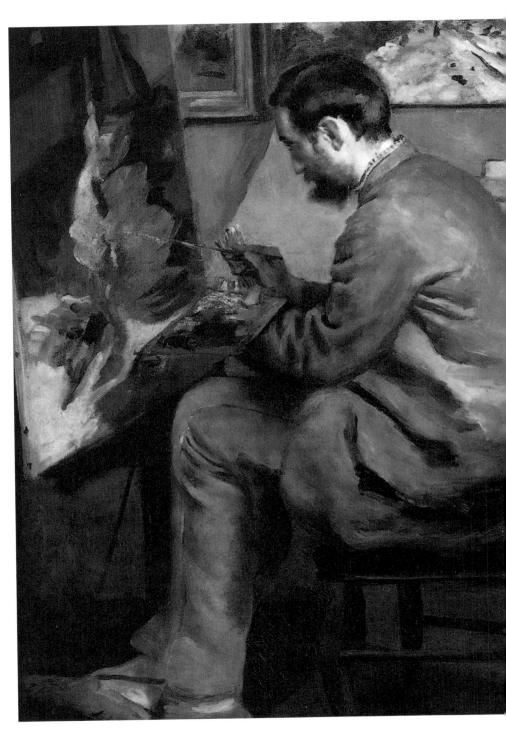

*Frédéric Bazille
at His Easel*
(detail)

Other colleagues, including Monet and Pissarro, fled to England. Renoir was called up and served for a year far from the fighting, in Bordeaux, where he painted his superior officer, *Captain Darras*, and his wife, *Madame Darras*.

The war was over in only one year, and by 1871, Renoir was back in Paris, about to embark on the most glorious decade of his artistic life.

TURNING TO IMPRESSIONISM

After the war, the same group of Parisian artists, except for Bazille, again gathered at the cafés, ready to form a cohesive movement, ready to use the "emotions of the eye." They were eager to create paintings that reflected the amazing, subtle changes in color as light changes, and that contained no distinct outlines, only sensations of color and figures at one with their surroundings.

Unfortunately, the Salon still did not have confidence in them. But there were art dealers who did. Paul Durand-Ruel became a good friend of all the Impressionists. As Renoir said, "He was the first picture dealer, the only one for many long years, to have faith in me."

Because in Paris the reception to the Impressionists' canvases was poor, Durand-Ruel bought them and showed them in London. Unfortunately, he went into debt in 1873 and could no longer help the struggling artists.

When the Salon continued to reject their work, the Impressionist group decided to have their own exhibition: the Salon des Refusés. It took place in 1874, in the studio of the photographer Nadar. On the red velvet walls, Renoir exhibited six pictures, including *Dancer*, with its creamy texture, its luminous blues, and its stunningly poised young ballerina, and *La Loge*. Here, Renoir went inside to capture natural light, which echoes on the woman's creamy, luminescent face, creases the rustling texture of her dress, and reflects in the pearls around her neck. The brushstrokes are thick with color in the background, on the loge, on the gentleman peering through binoculars, and on the neutral background of the box.

Renoir's paintings, incorporating a more realistic style, fared better than his friends' works, but they were all ridiculed. One

Portrait of
Victor Choquet

critic sneeringly called them Impressionists, taken from Claude Monet's unorthodox painting *Impression: Sunrise*. The show was a dismal failure.

In 1875, in an attempt to stir up interest in their work, the group organized an auction at the Hotel Drouot. Unfortunately, this showing was worse than the previous one. Renoir presented nineteen paintings for sale—which were bought for an insulting total of two thousand francs. He received three hundred francs for *Pont-Neuf*, an Impressionist landscape, and fifty francs for his contemplative *Woman Walking in a Field*. In the end, Renoir used his profits to buy back the paintings that he had sold for practically nothing.

But at the Hotel Drouot Renoir did meet Victor Choquet, an important collector and great admirer of Impressionist art. He asked Renoir to paint a portrait of his wife. The result was *Portrait of Madame Choquet in White*. In the right-hand corner is a ceiling sketch done by Delacroix, whom Choquet greatly admired and believed Renoir's work closely resembled. A few years later, Renoir painted the *Portrait of Victor Choquet*, one of his best male portraits. For a painter who never really tried to reveal the personality of a sitter, it shows a rare degree of psychological penetration.

A MODICUM OF FINANCIAL SECURITY

Despite the failure of the Salon des Refusés, 1875 was a good year for Renoir. A large commission for a group portrait enabled him to buy a house with a garden. Here, in 1876, he painted *The Swing* and the sensuous, impressionistic *Nude in the Sun*. And in his garden, he also put the finishing touches on his famous *Moulin de la Galette*, which he sketched at the open-air dance hall. He recruited his friends, as well as the shop clerks, the milliners, and the flower girls who came to dance on Sundays, to pose for him. The result is pure, unadulterated joy. Indeed, in this painting, Renoir perfectly captures the excitement and exuberance of a free Sunday afternoon in nineteenth-century Paris.

Unfortunately, the second Impressionist exhibition, in 1876, fared no better than the previous sales. To this show Renoir submitted seventeen oil paintings, six of them lent by Choquet. Once again, his paintings did not appeal to the general public, but he met yet another influential collector.

THE PUBLISHER CHARPENTIER

Georges Charpentier and his wife, Marguerite, came to the second exhibition and instantly became admirers of Renoir's work. Soon he became a part of their circle. He went to many dinner parties at their home, where he met the writers Zola, Flaubert, and Maupassant, as well as the actress Jeanne Samary, whom he painted in 1877. Indeed, he was commissioned to paint many of the people he met at the Charpentiers'. And in the third Impressionist exhibition in 1877, he showed twenty-one new paintings, including *Portrait of Jeanne Samary*, as well as *Moulin de la Galette* and *The Swing*.

Although the show was once again disappointing, Renoir was on his way to becoming a successful portrait painter, especially of women and children. As a painter, Renoir was usually interested only in the appearance of the sitter. When he painted a woman, he concentrated on the texture of her skin, the highlights in her hair, the rich fabrics of her clothing—each enhancing the other, all of them building to create a fresh beauty that provided its own message and rose above mere time and place. In *Portrait of Madame Georges Charpentier with her Daughters*, for example, the figures have a worldly air. Their skin is pink and luminescent. The girls have an innocent, graceful air with not a hint of artifice. The clothes have texture, and the carpet, the table, and the flowers share the focus with the grouping on the couch. They are as vibrant as the sitters.

But the most famous Renoir painting was yet to come.

LUNCHEON OF THE BOATING PARTY

The Impressionists loved to paint water. They liked to paint scenes that moved with changing light, that bustled with activity, that reflected the sun in myriad colors. Renoir was no exception—and in 1881 he produced his quintessential Impressionist painting in *The Luncheon of the Boating Party*. The scene is his favorite restaurant, Alphonse Fournaise, on Chatou, a river island in the Seine. He painted it on the spot, using to full effect the light that drifted through the awning. Indeed, the painting is infused with light, which is reflected from the carafes of wine, the glasses, the

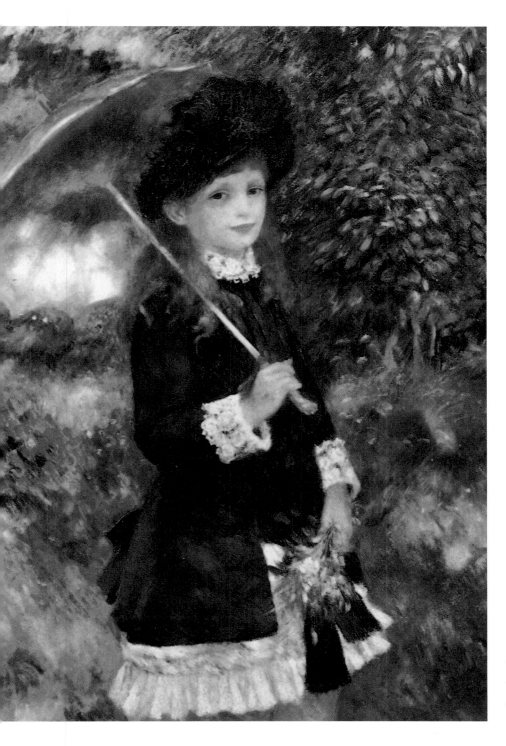

Young Girl
with a
Sun Shade
(detail)

women's hats. Here is a beautiful summer day; here is a group of people enjoying their time together. The brushstrokes are slightly blurred, giving a subtle diffusion to the painting and adding a vibrancy to the whole composition. It almost seems as if the characters will begin to move, to nod their heads in conversation. Aline Charigot, the woman in the foreground holding the dog, would become Renoir's wife. She, too, is full of movement; she is ready to kiss her dog.

The Luncheon of the Boating Party is a masterpiece. As Theodore Duret wrote in his biography of Renoir, published in Paris in 1924, ". . . one cannot imagine these women, as they are here, having been painted by anybody else. They have the free and easy manners one would expect of young women who have lunched and are enjoying themselves with a group of young men, but they also have that graciousness, that roguish charm, which Renoir alone could give to women."

By 1881 Renoir had achieved enough financial success to travel. In the autumn, he went to Algeria and then to Italy. He was profoundly affected by Raphael's paintings in the Vatican and by the frescoes at Pompeii. He was beginning to become dissatisfied with Impressionist imagery and he turned once more to nudes, which had little place in the Impressionist world of landscapes and daily, spontaneous life. In 1881, he painted a series of studied nudes, including *Blonde Bather*, an exquisite, brilliant work.

But Renoir's love affair with Impressionism was not yet over. He showed his *Luncheon of the Boating Party* at the seventh Impressionist exhibition in 1882, and in 1883 he painted three more impressionistic masterpieces: *Dancing at Bougival*, with its shimmering swirls of materials; the detailed *Dancing in the Country*; and the sophisticated, elegant *Dancing in Town*—each of them perfectly capturing the culture and mood of the moment.

Renoir's Impressionist period lasted from 1872 to about 1883. But he was never strictly an Impressionist. He always experimented with a variety of techniques to create his paintings. Sometimes he would apply color in thick, splashy strokes. Sometimes he would apply it in thin, almost translucent layers. Sometimes he would brush color on in distinct, separate daubs. And sometimes his brushstrokes would be so smooth that they melded together in one vision. The results might not have been

purely impressionistic, but they were great—and uniquely his.

Renoir's dissatisfaction with Impressionism continued to grow. He was particularly concerned that the movement was not sufficiently focused on form, and by 1883 he turned his back on it. He did not want to lose his figures to Impressionism's amorphousness, to its implied impression of images. He needed to clarify his figures once again. This stage of Renoir's career became known as his "harsh period."

A NEOCLASSICAL STYLE

The Raphael masterpieces Renoir saw in Rome stayed with him. He realized that he had a lot to learn about form, outline, and composition. "I am just like the children at school," he wrote, "still using daubs, and by now I am forty."

Renoir was not alone in his disenchantment with Impressionism. Many young artists needed to go beyond its constructs and they created their own styles. Degas brought his paintings into the studio, preferring artificial light to natural sun. Seurat began to paint his large canvases using his dotted pointillism technique. Van Gogh began to use bold slabs of color that had little to do with the objects he was painting. Cézanne became more and more abstract, painting geometric patterns that would lead to Cubism and modern twentieth-century painting.

But in 1882, Renoir was still struggling with composition, trying to initiate hard lines in his figures but unable to repress his impressionistic tendencies. *The Umbrellas*, completed in 1883, shows this dichotomy. The women on the left side of the canvas are more outlined; each brushstroke is defined and hard. But the women on the right are purely impressionistic, from the glint of light on their hats to the texture of their clothes.

By the end of 1883, Renoir was at a complete standstill. "I have come to the very end of Impressionism," he subsequently wrote, "and came to the realization that I could neither draw nor paint. In a word, I had come to a deadlock."

Renoir's way back was to return to the classical world of Raphael. The result was the evocative, classically drawn *Bathers*, which he began in 1884 but did not complete for three years. The three nude women have hard outlines. The painting's finish is also

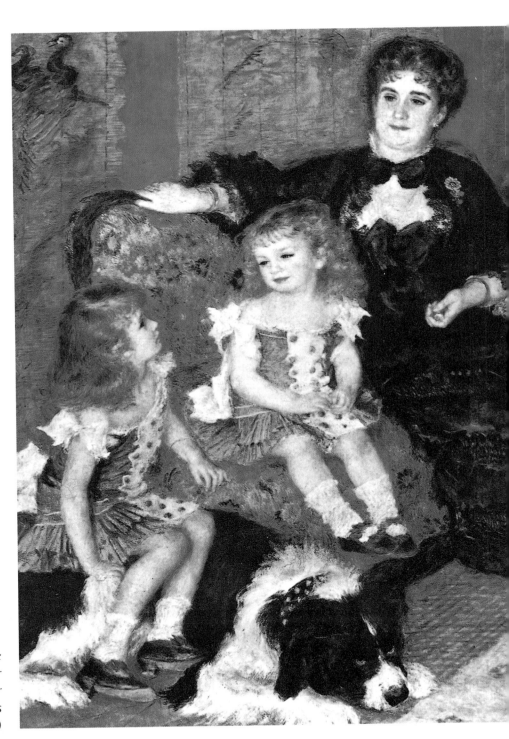

Portrait of Madame Charpentier with Her Daughters (detail)

hard and unyielding and it has a two-dimensional quality. The background, however, is looser. There are feathery strokes in the trees and the water, but the overall quality is still hard and unapproachable.

While Renoir was grappling with the crisis in his artistic life, his personal life was flourishing. He married Aline, and their first child, Pierre, was born in 1885. His happiness with his growing family and his newfound contentment at home began to be reflected in his paintings and provide an answer to his deadlock.

A New Vision

It was time for a change. Renoir could not repress his natural spontaneous inclinations for long. But his sojourn into classic composition was not wasted. Now, in his middle years, he created a new form, part Impressionism, part neoclassicism, that, together, became sensuous and iridescent.

It began with his paintings of *Motherhood* in 1885 and 1886; the lush brushstrokes combined with the clear, luminous lines of his wife and baby. These and his Bather series, including *Bather with Long Hair*, *Blonde Girl Combing Her Hair*, and *Nude in the Water*, show that although his forms are still strong, they are not cold. The contours are still rounded and full, the skin tones are glowing with pearlized color; the figures seem to be creamy and soft and radiate nuances of light. Renoir's models during the late 1880s and early 1890s were beautiful, prosperous creatures, transfigured and elevated to the level of artistic symbols. They inhabited a timeless dimension.

Renoir continued to paint in this style for thirty years. He discovered that paint itself, when applied in dense, vibrant strokes, could create form and design images. Renoir's figures quivered with emotion, inhabiting the same life as the background. This style is clearly seen in *The Apple Vendor* of 1890. Here, in this soft and romanticized painting, everything is contentment. Renoir's wife and child literally shimmer with pearly light in the afternoon sun.

In the summer of 1894, Renoir's son Jean was born, inspiring another group of exuberant, nurturing paintings. About this time, Aline's cousin, Gabrielle, came to their home in Cagnes-sur-Mer in the South of France. She planned to stay only a short time, but she

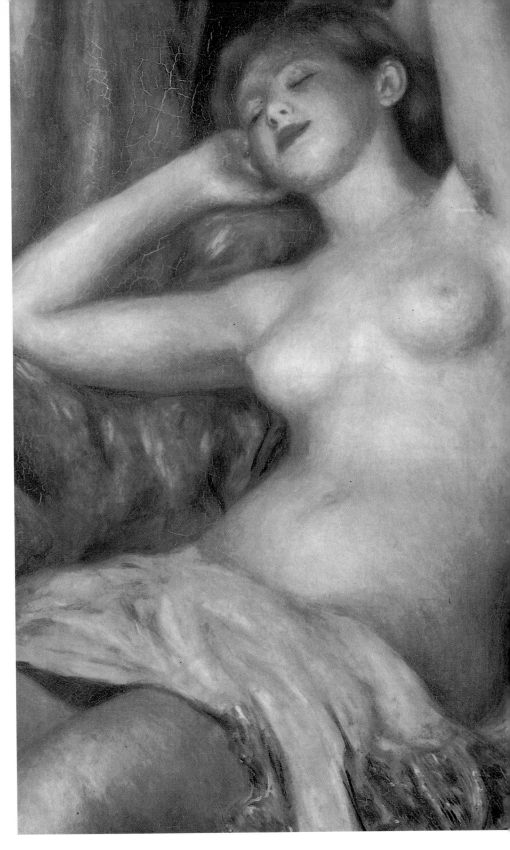

Nude Asleep
(detail)

soon became Renoir's favorite model. He often asked her to sit with the children and keep them occupied while he painted them.

The paintings Renoir did of Gabrielle are exquisite examples of his new style. In *Gabrielle with a Rose*, she is part of the texture around her; the rose is as pearlized as her skin. In *Gabrielle and Jean*, her face literally glows. The canvas, too, seems to vibrate with emotion, due in part to the soft brushstrokes and full lines, and to the contrasting, soft colors; the red of Gabrielle's shirt serves as a counterpoint to Jean's glowing white nightshirt.

Nude in the Grass and *Bather Sitting Drying Her Leg*, painted in 1905, epitomize Renoir's new style, the pearlized quality to his figures' skin, their lush, full bodies, the soft brushtrokes that burst with tenderness and sensuality—all these characterize this final stage of his artistic life.

THE LAST YEARS

Sadly, just as Renoir was embarking in his most rewarding artistic direction, he succumbed to crippling arthritis. The symptoms began in 1888, and by 1910 he was confined to a wheelchair.

Renoir reacted to his disability with the same vitality and aplomb he had shown throughout his life. Enraptured by beauty, pervaded by a profound love of nature and humanity, he would not grow sad—ever. Indeed, he had his brushes tied to his paralyzed hands and continued to create great works of art.

His work continued to receive great acclaim in these last years, but personal adversity also struck. Aline died in 1915 and his sons, Pierre and Jean, went off to war. But the paintings remained, fluid and sensuous, joyous to the end. Renoir's last great masterpiece, *The Bathers*, was done on a large canvas, with the aid of a device that moved the picture so he could work on different areas. The painting offers strikingly powerful images: the swirling, curved strokes are firm and the bodies are opulent and magnificently classical. The red-haired girl in the foreground, Andrée Hessling, later married Jean, who became a great filmmaker.

During these last years, Renoir even created sculptures by guiding the hands of his assistant, Guino, as he molded the plaster shapes.

And, finally, Renoir was able to see one of his paintings, *Portrait*

31

of Madame Charpentier, mounted in the Louvre in August 1919. It was the triumph of his life in art.

His rich, full life ended on December 3, 1919, at his lovely Cagnes-sur-Mer.

To some people, Renoir was the archenemy of realism. To others, he was the rejuvenator of Ingres and Raphael. Still others regarded him as a traitor to Impressionism, "selling out" to the Salon culture. Even the budding women's-rights movement found fault with his voluptuous models.

But all Renoir ever wanted was to paint—and to enjoy himself. This theme is reflected in his paintings, which are always so full of life. Death never appears, not even as a shadow, because the shadows themselves are colors. Evil and torment are missing. Everything exists in a perfect world of joy and harmony. It is a world reflected back on anyone who gazes at a Renoir painting.

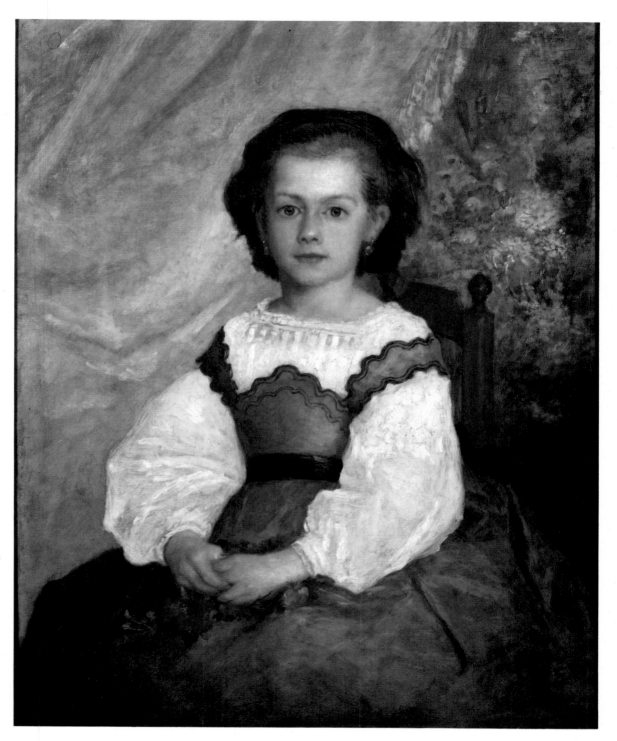

Portrait of Mademoiselle Romaine Lacaux

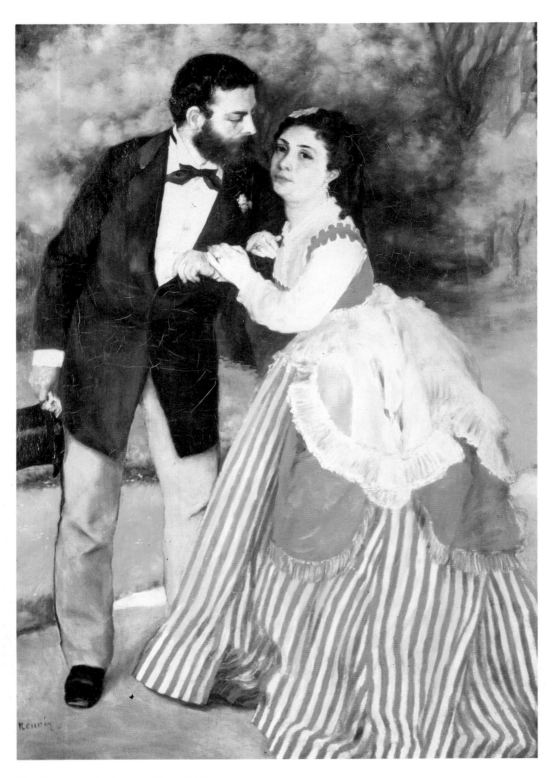

The Painter Sisley and his Wife

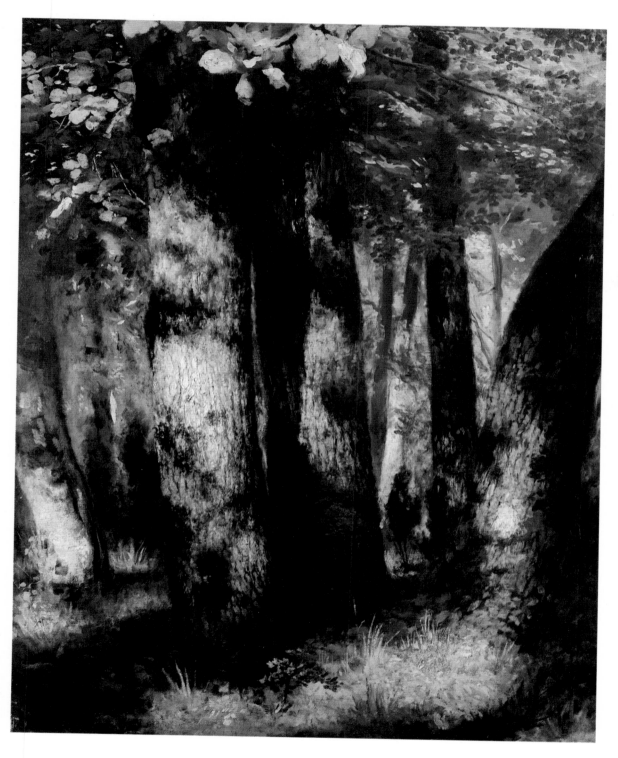

In the Forest of Fontainebleau

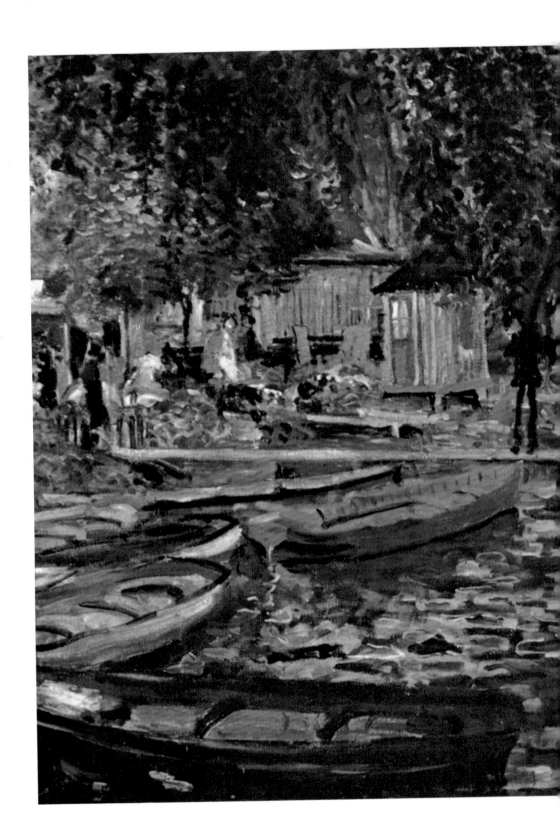

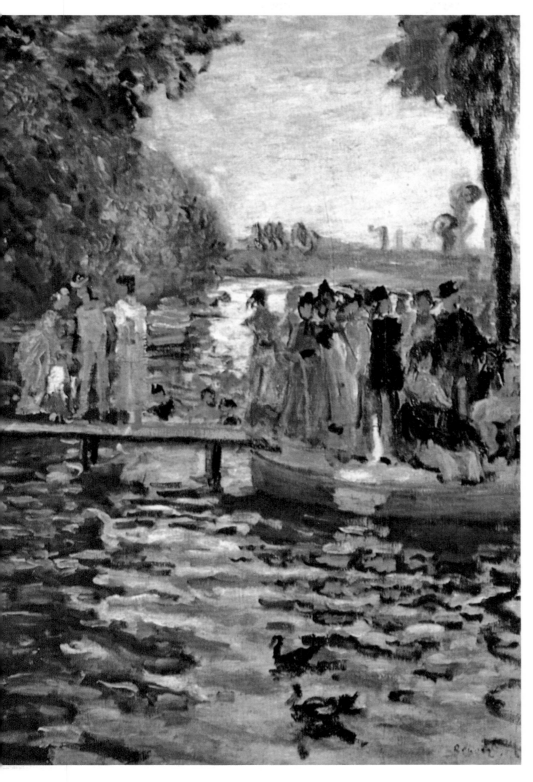

La Grenouillère

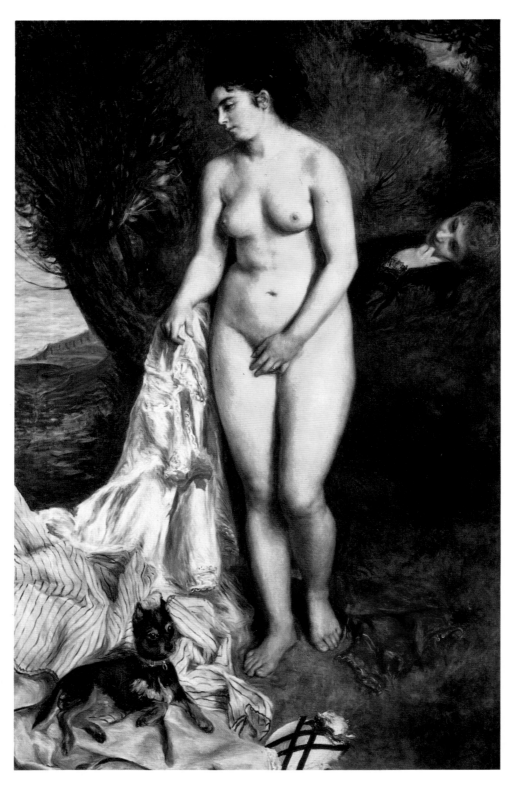

Bather with a Griffon Terrier

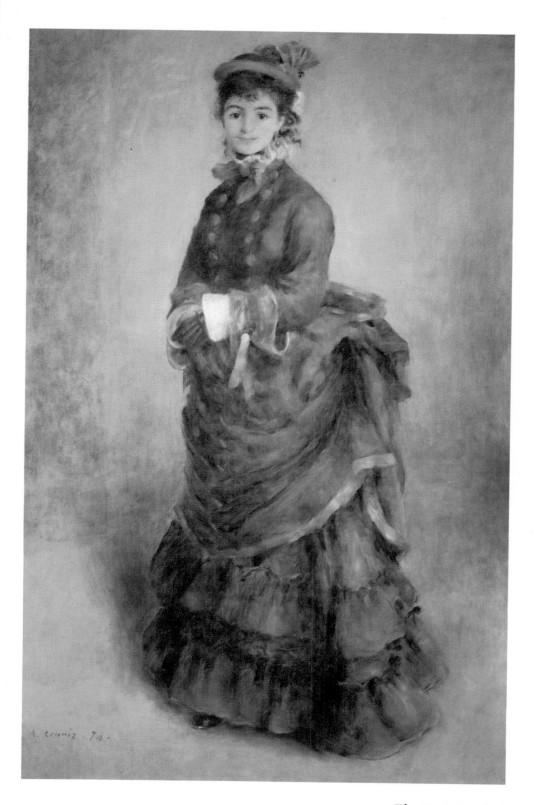

The Parisian Girl

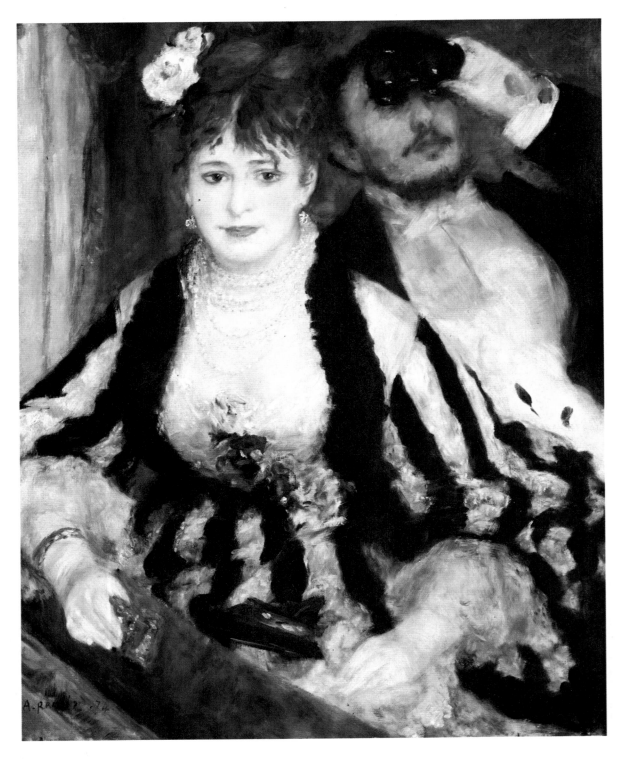

La Loge

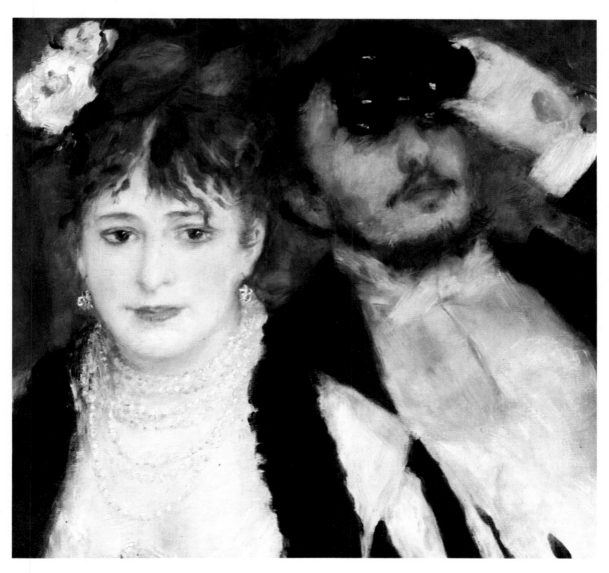

La Loge (detail)

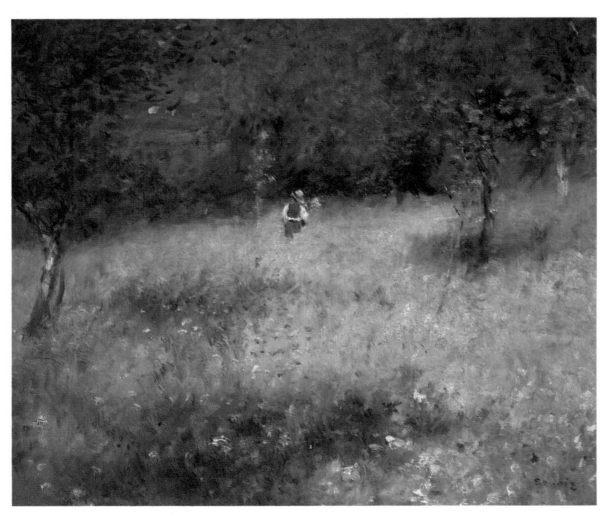

Spring in Châtou

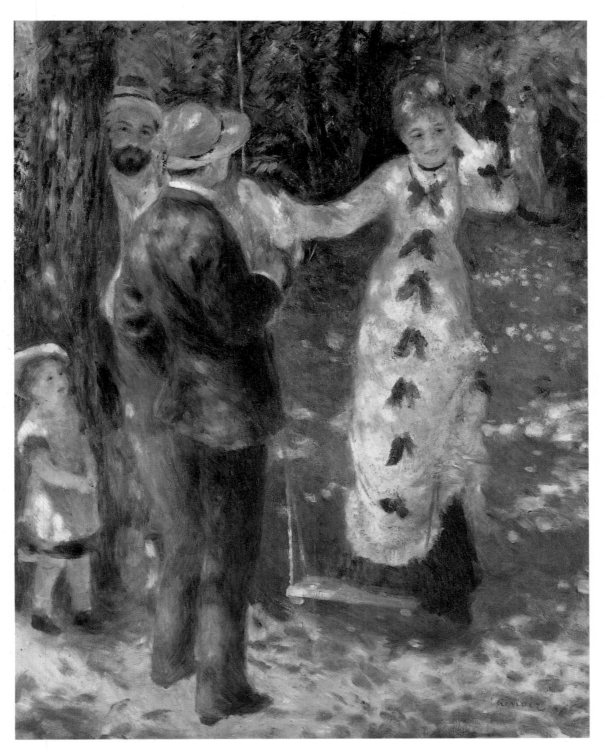

The Swing

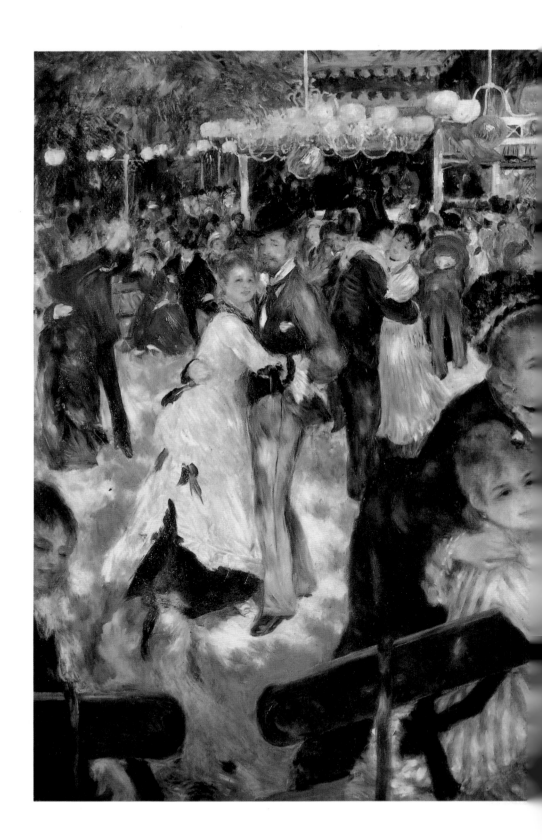

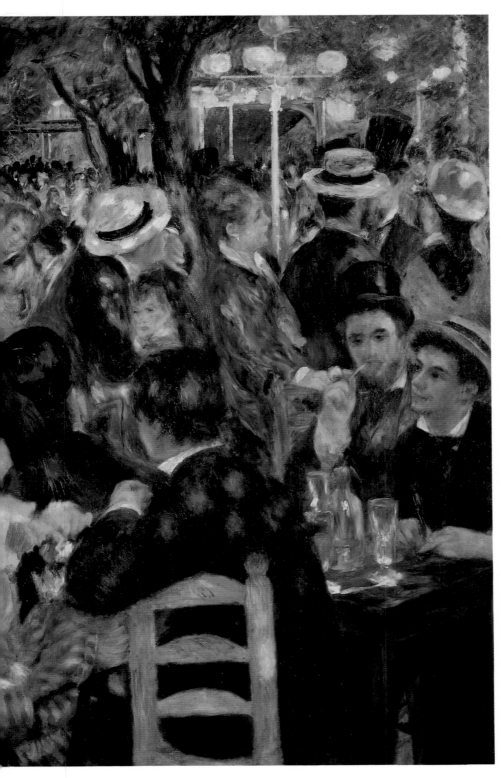

Le Moulin de la Galette

Girl with a Watering Can

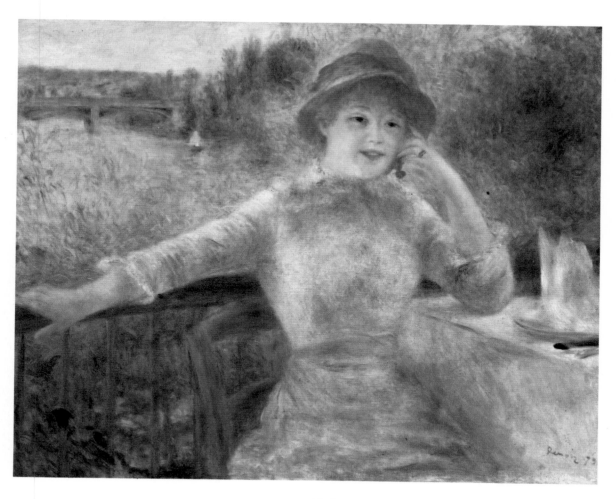

Alphonsine Fournaise on the Island of Châtou

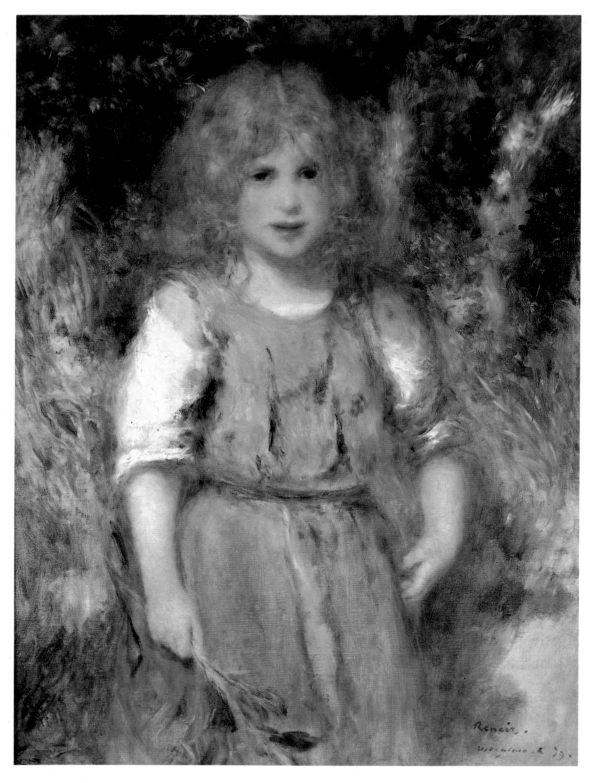

Gipsy Girl

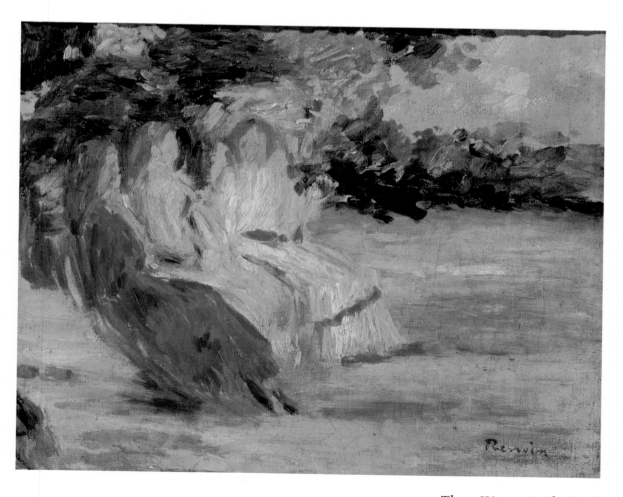

Three Women in the Park

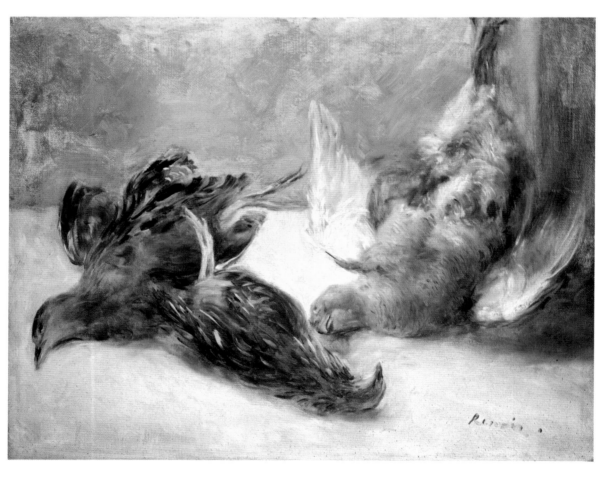

Still Life with Pheasants

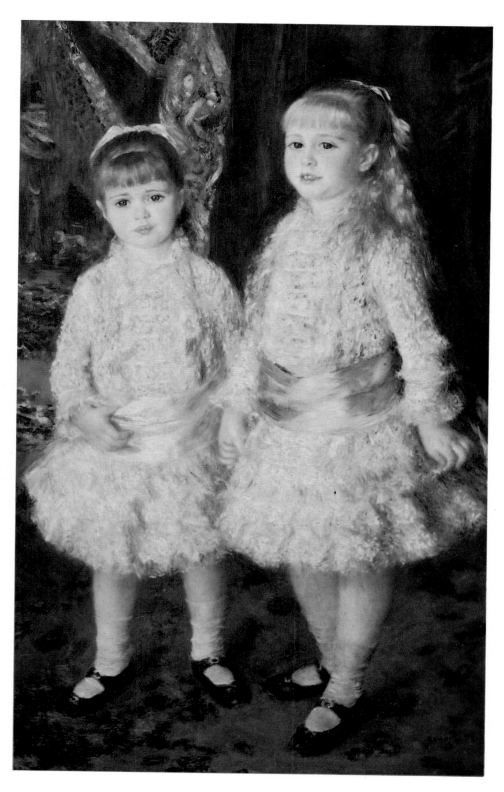

The Cahen d'Anvers Girls

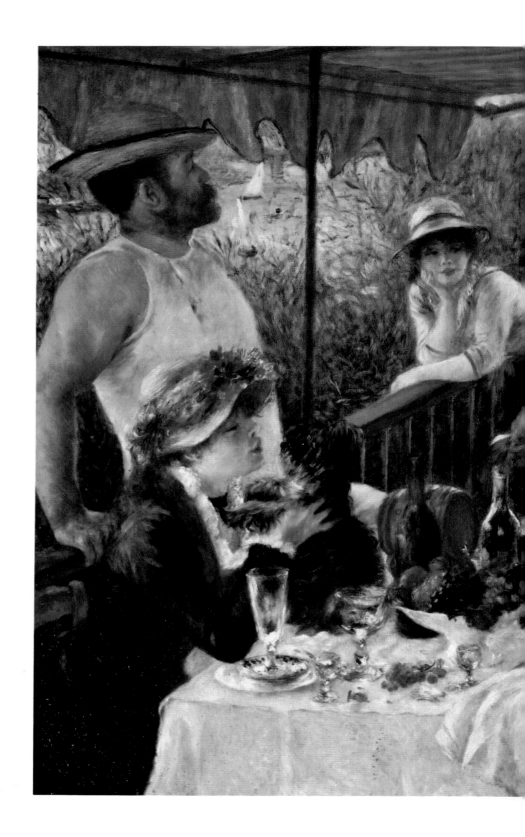

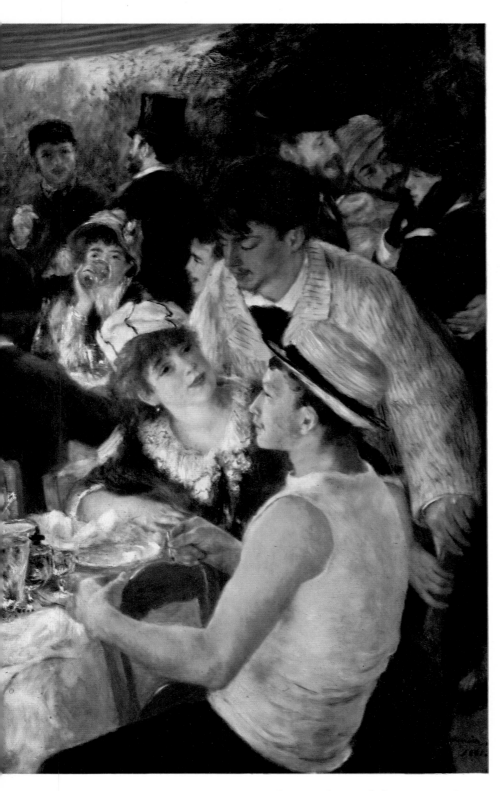

The Luncheon of the Boating Party

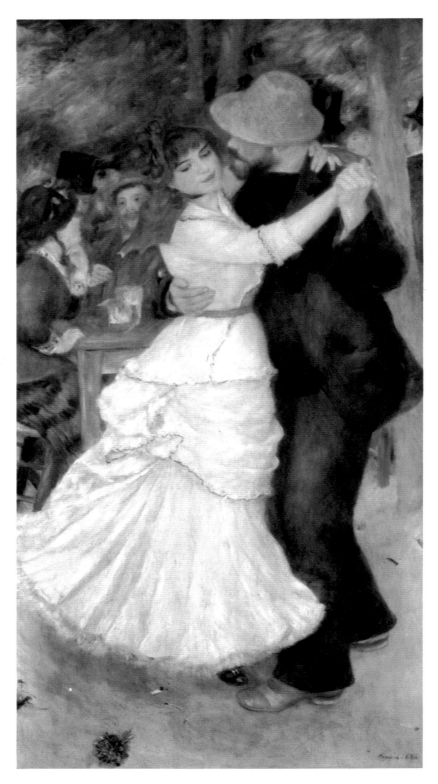

Dancing at Bougival

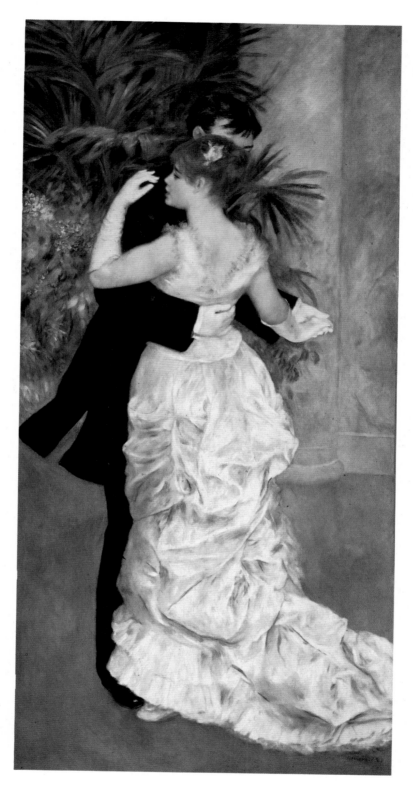

Dancing in Town

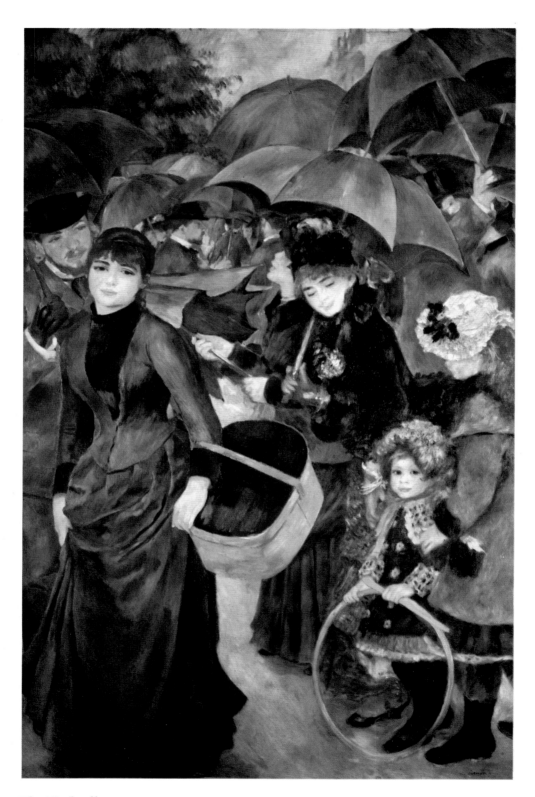

The Umbrellas

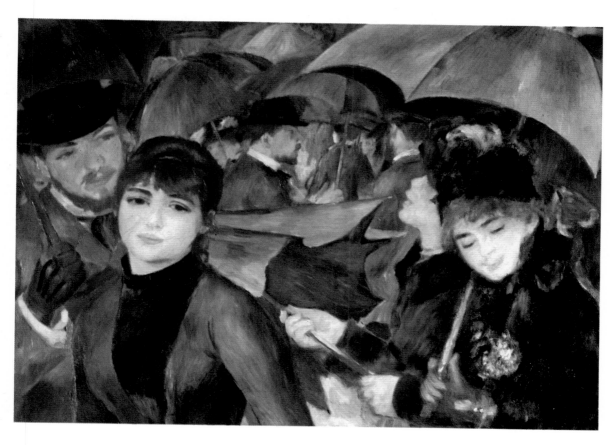

The Umbrellas (detail)

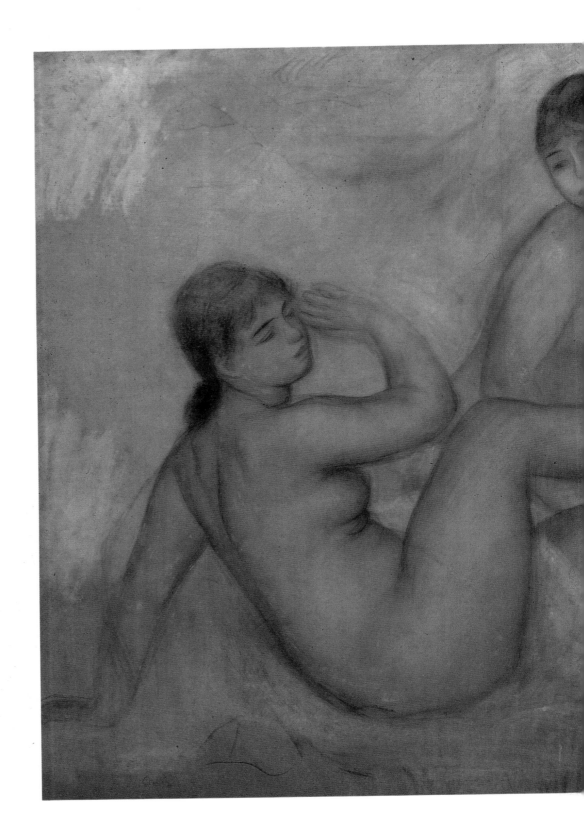

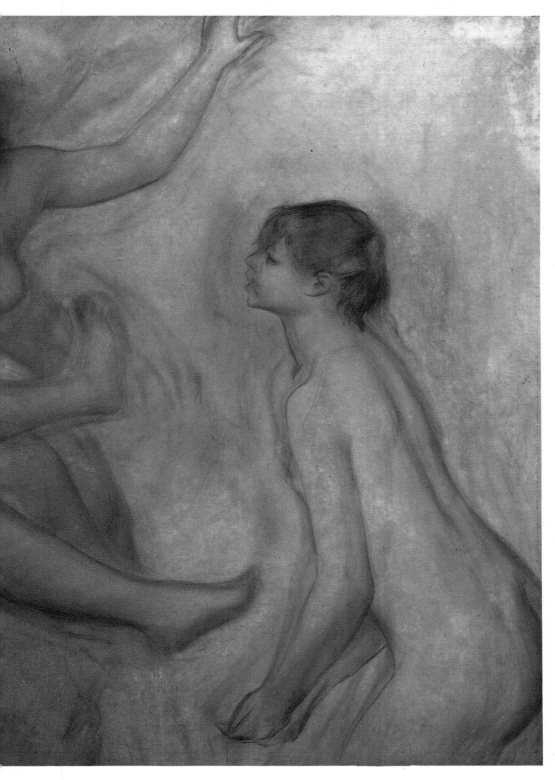

Sketch for The Bathers

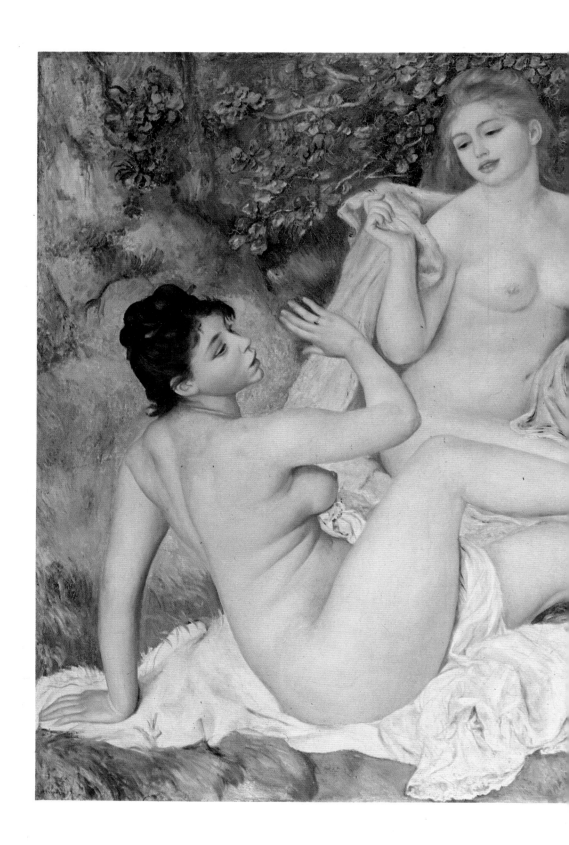

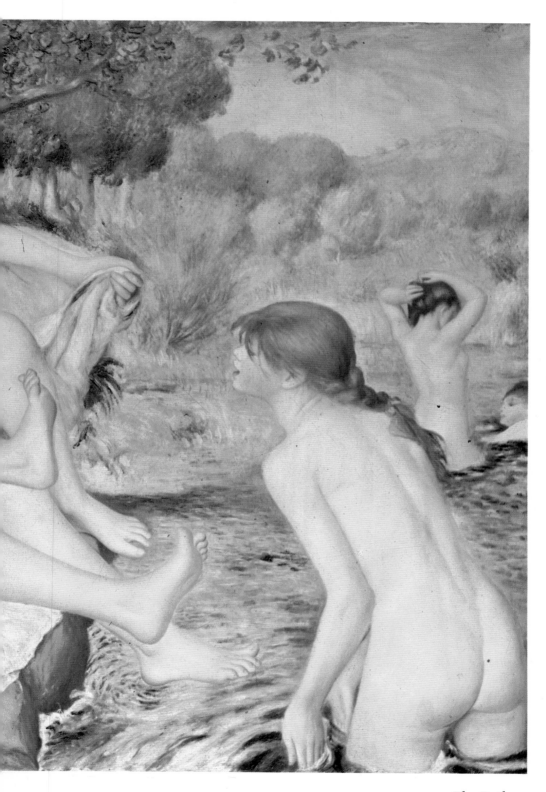

The Bathers

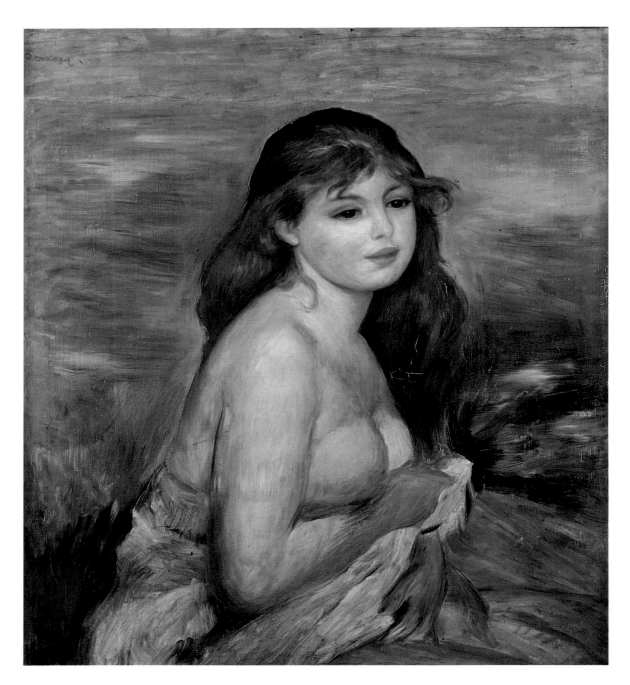

Girl Bathing

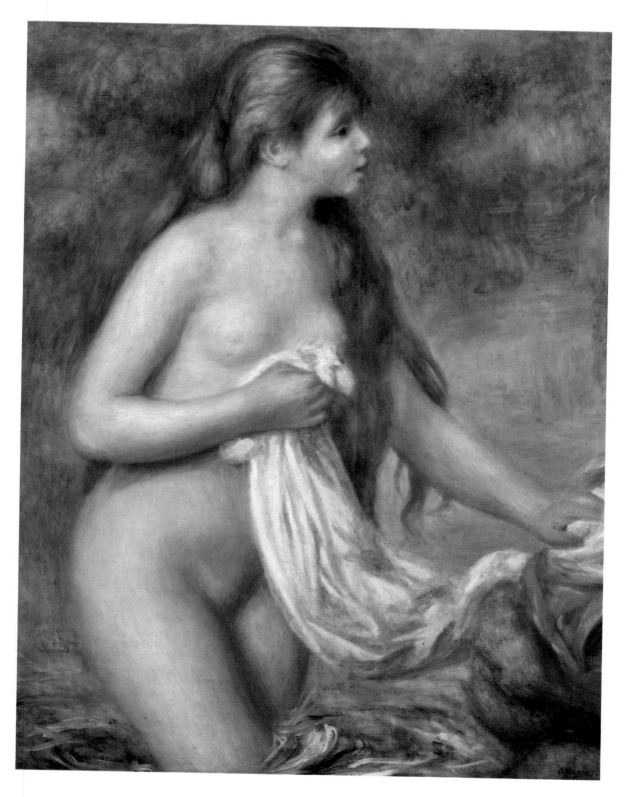

Bather with Long Hair

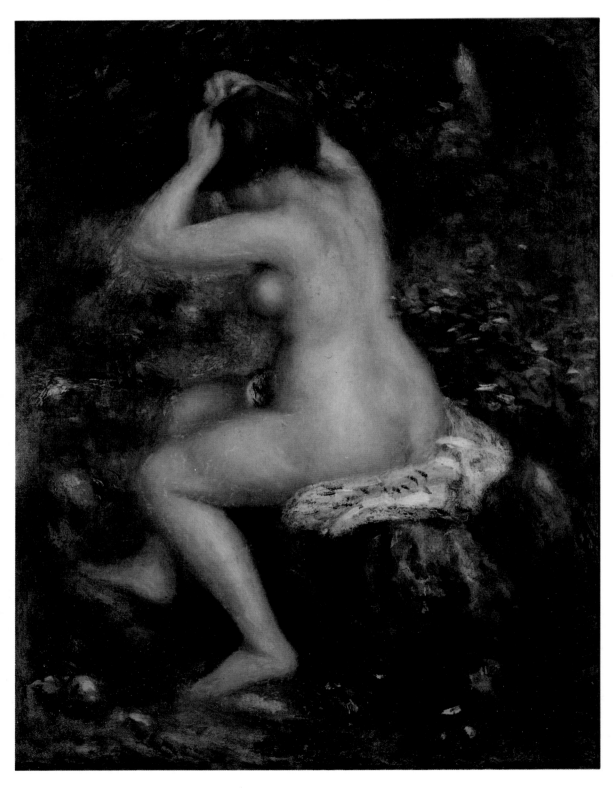

Nude

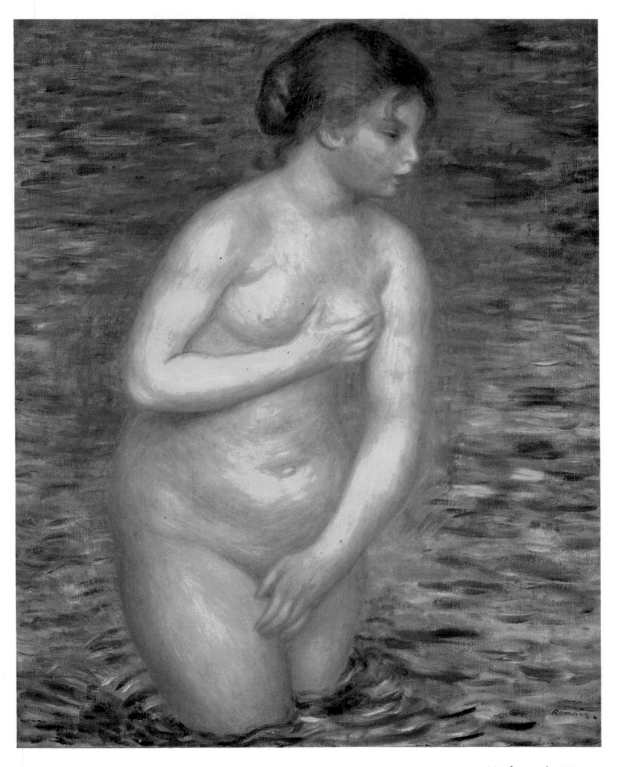

Nude in the Water

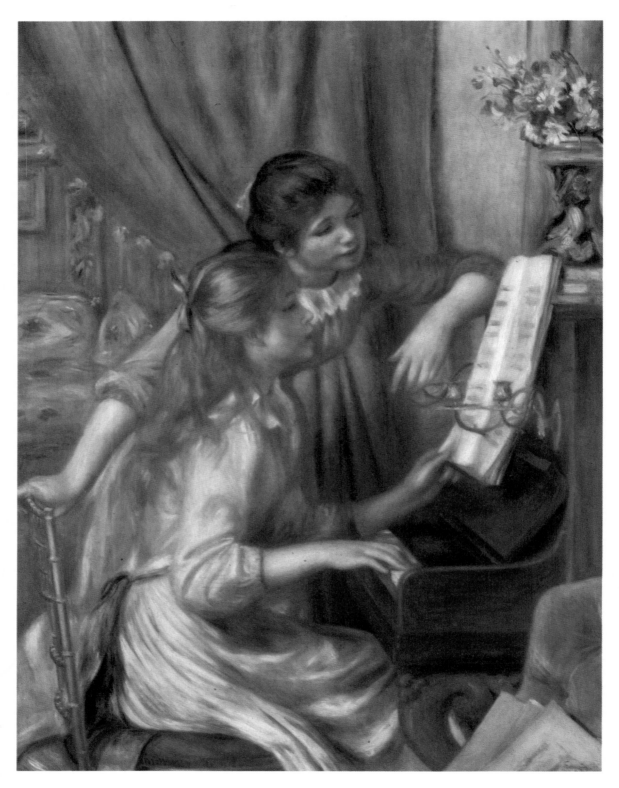

At the Piano

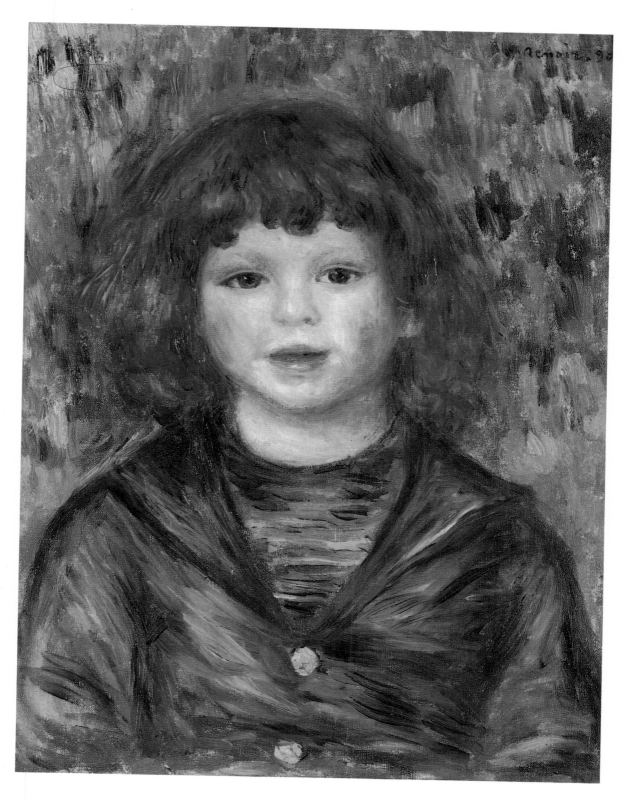

Pierre Renoir

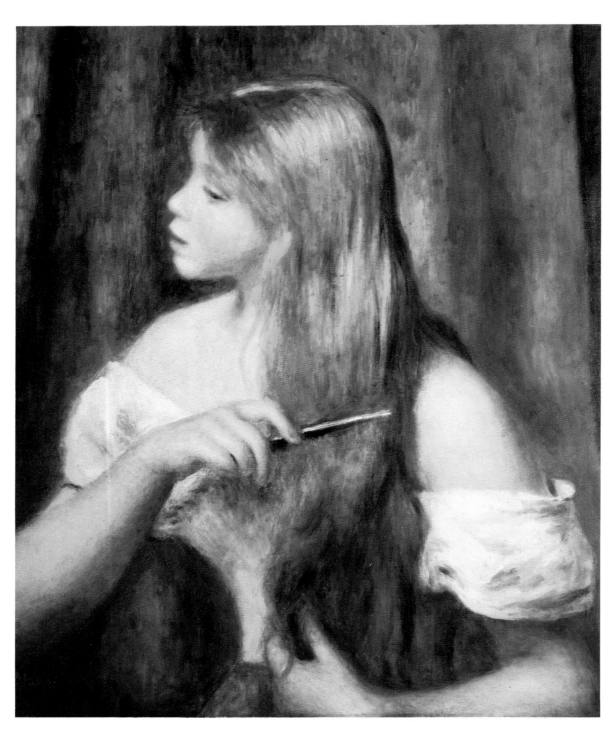

Blonde Girl Combing Her Hair

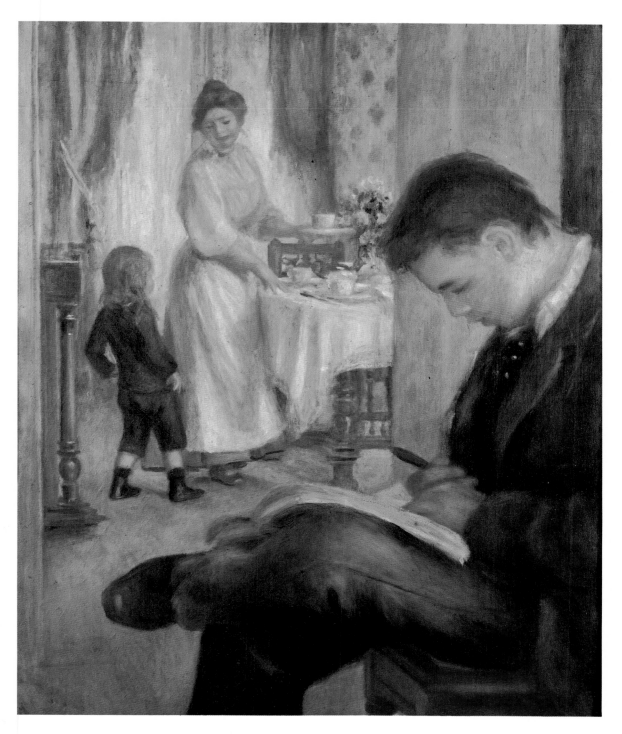

The Breakfast at Berneval

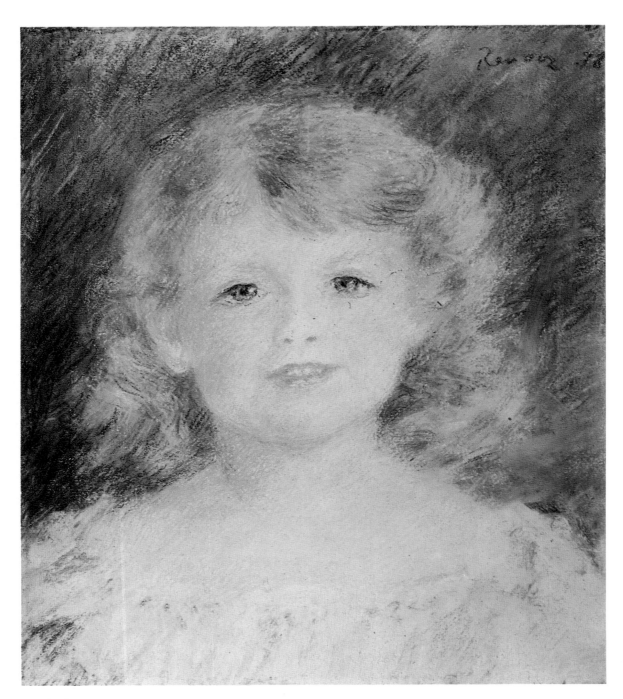

Paul Charpentier

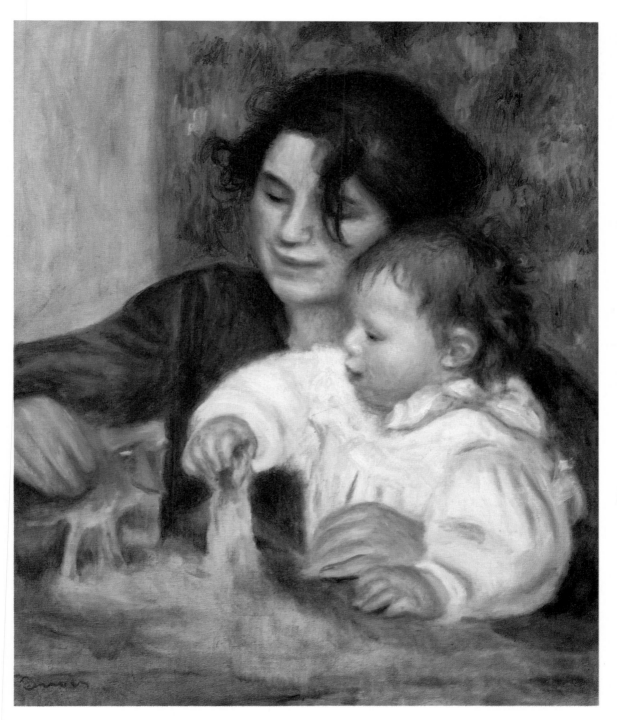

Gabrielle and Jean

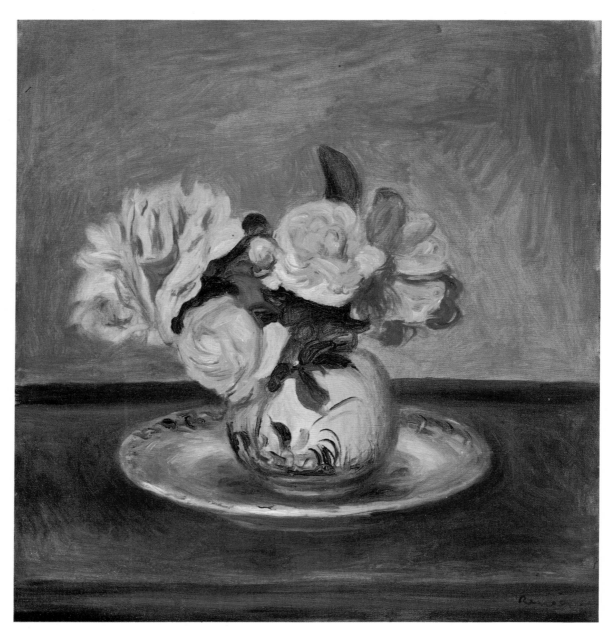

Vase of Flowers

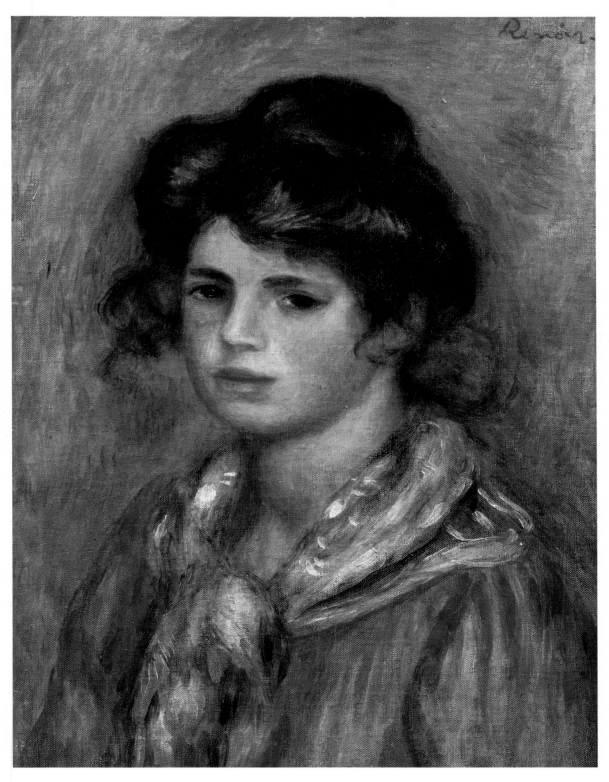

Gabrielle

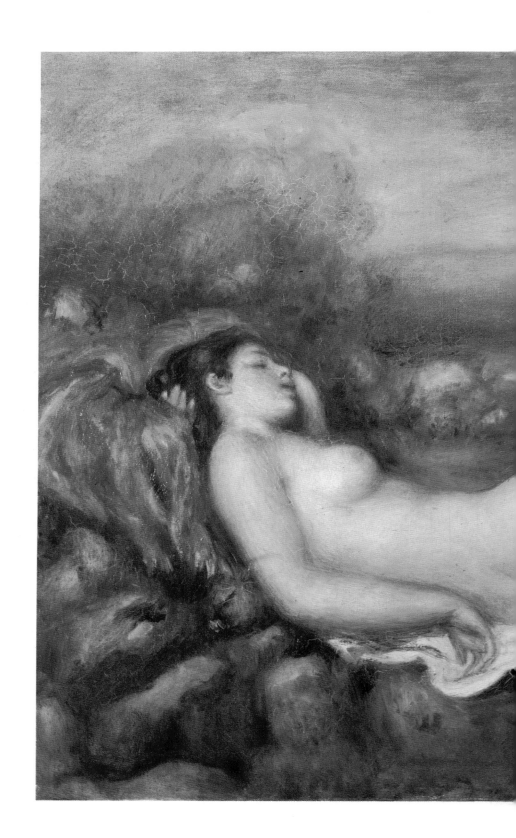

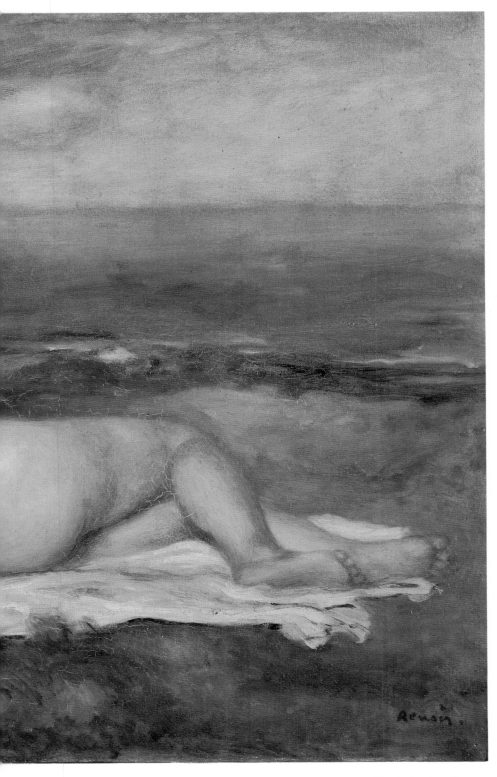

Nude in the Grass

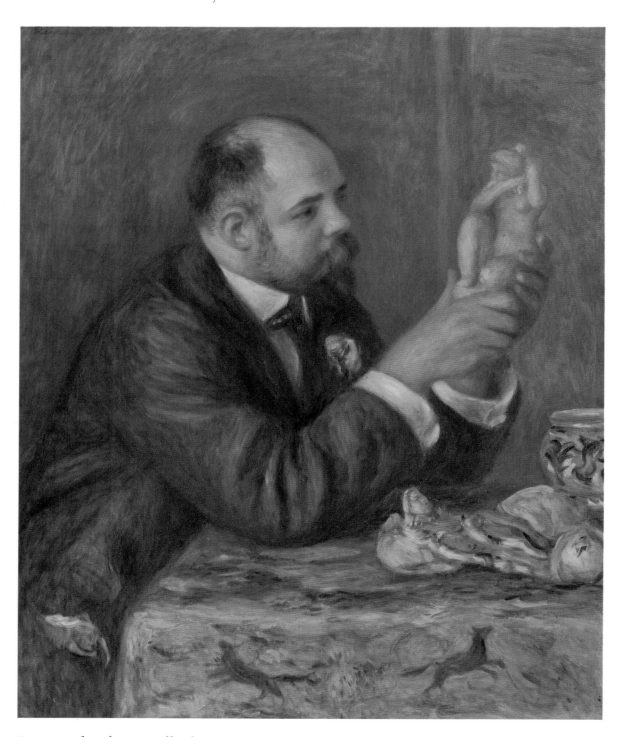

Portrait of Ambroise Vollard

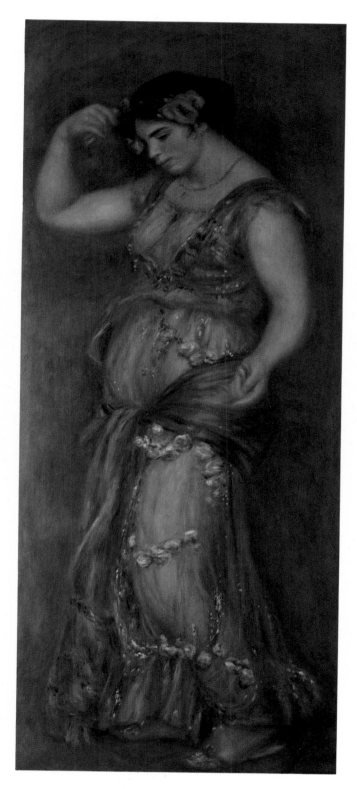

Dancer with Castanets

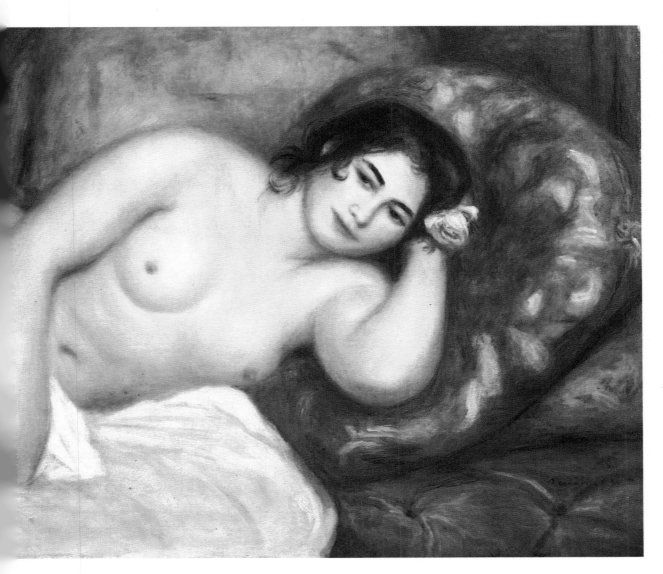

Female Nude on a Couch

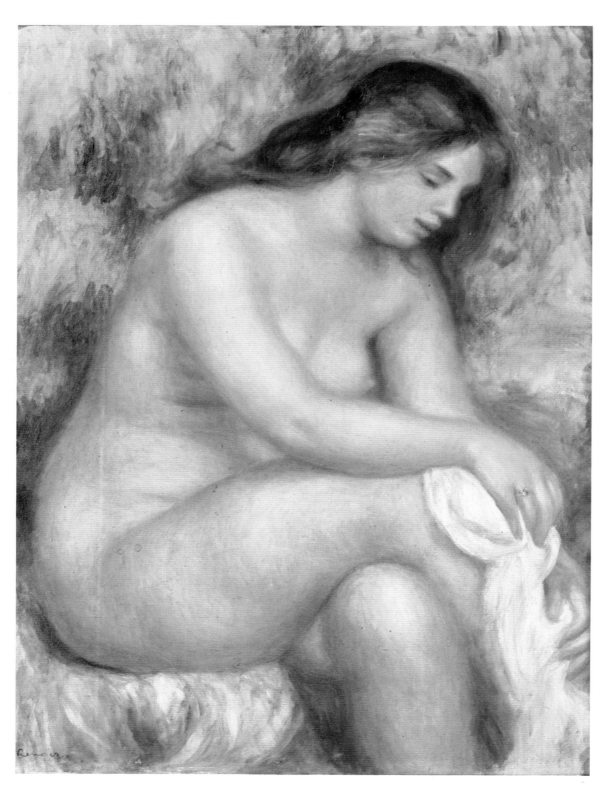

Bather Sitting Drying Her Leg

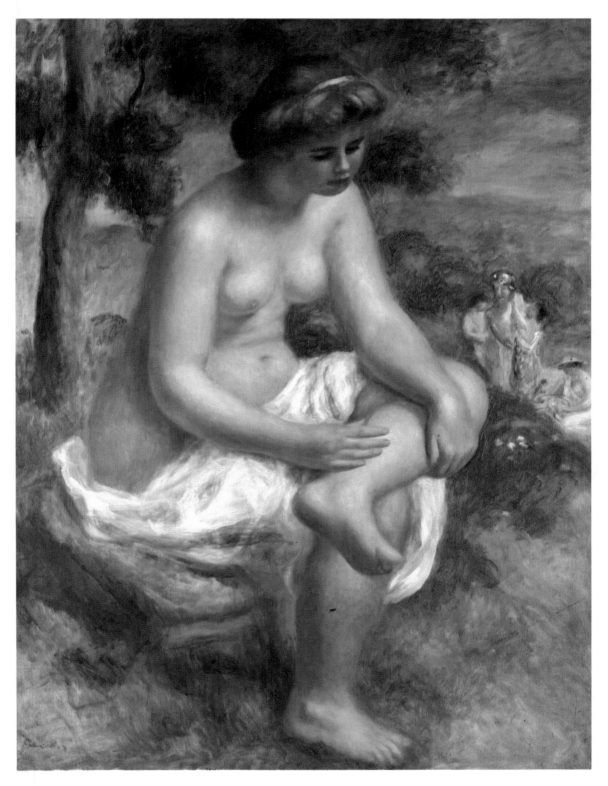

Bather Called Eurydice, Sitting in the Country

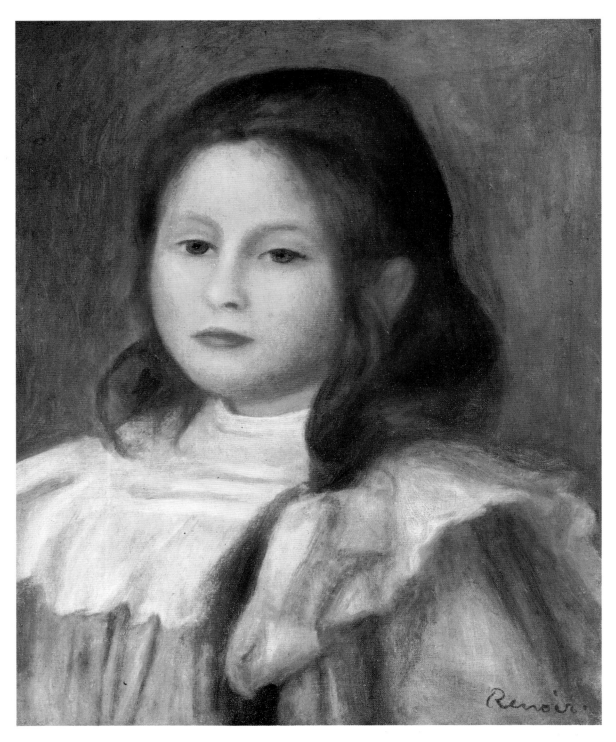

Portrait of a Child

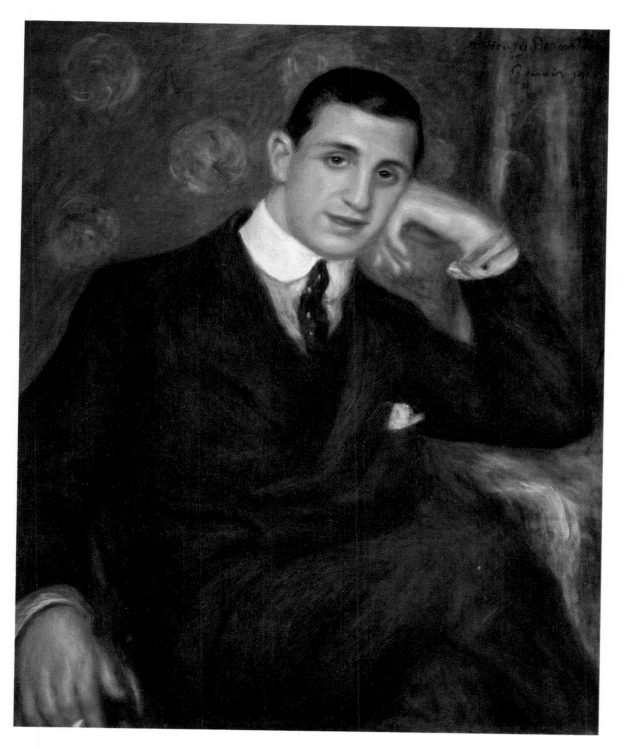

Portrait of Henry Bernstein

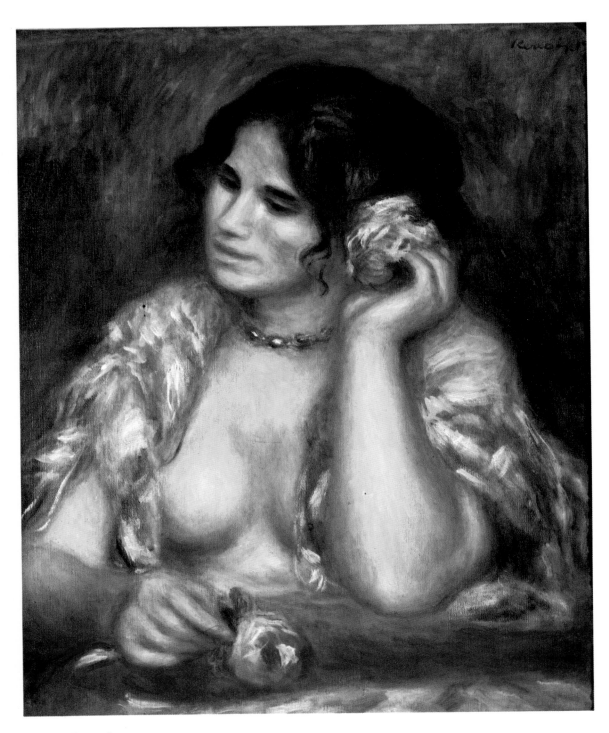

Gabrielle with a Rose

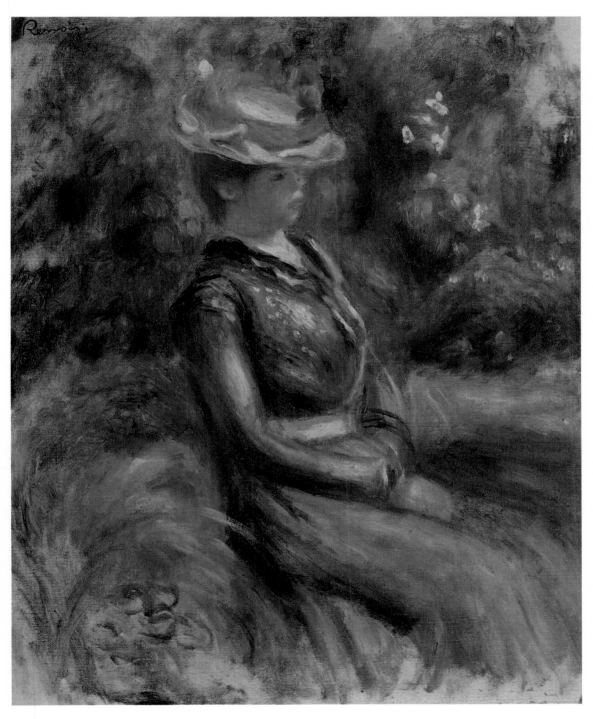

Girl Wearing a Straw Hat

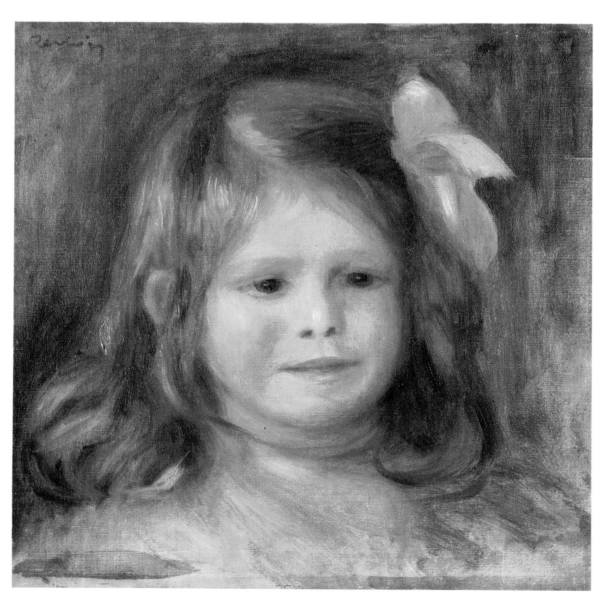

Girl with a Pink Ribbon

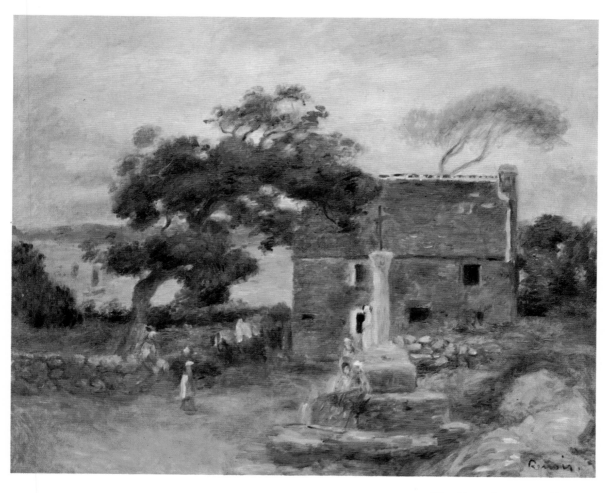

The Farmhouse at Cagnes

Apples and Pears

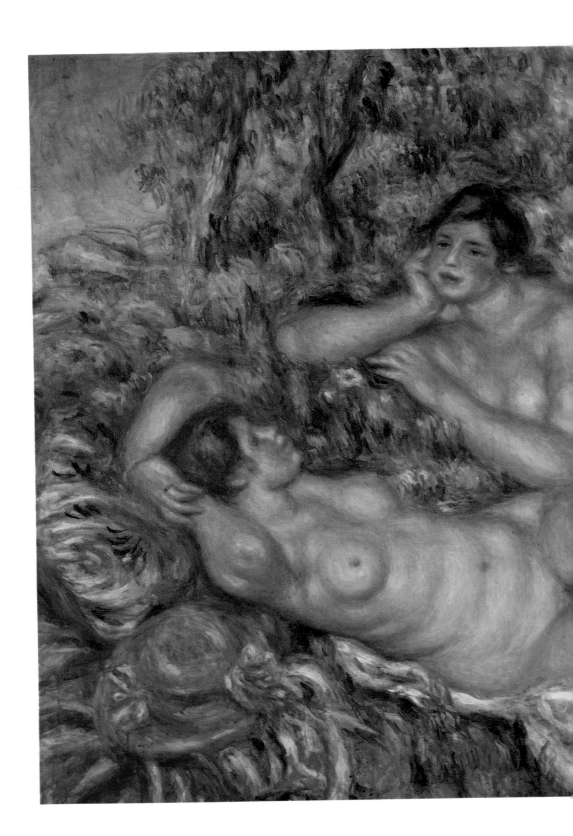

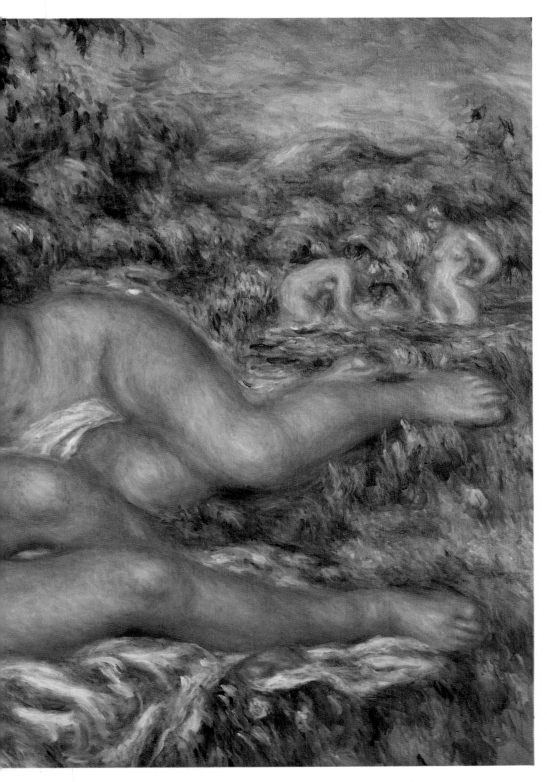

The Bathers

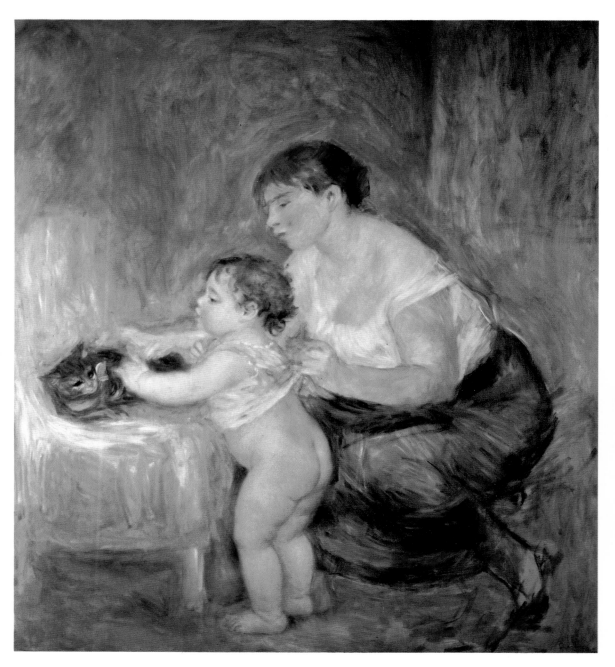

Mother and Child